DESIGN BY NATURE

RICHARD WOLDENDORP

VICTORIA LAURIE

FREMANTLE ARTS CENTRE PRESS
IN ASSOCIATION WITH SANDPIPER PRESS

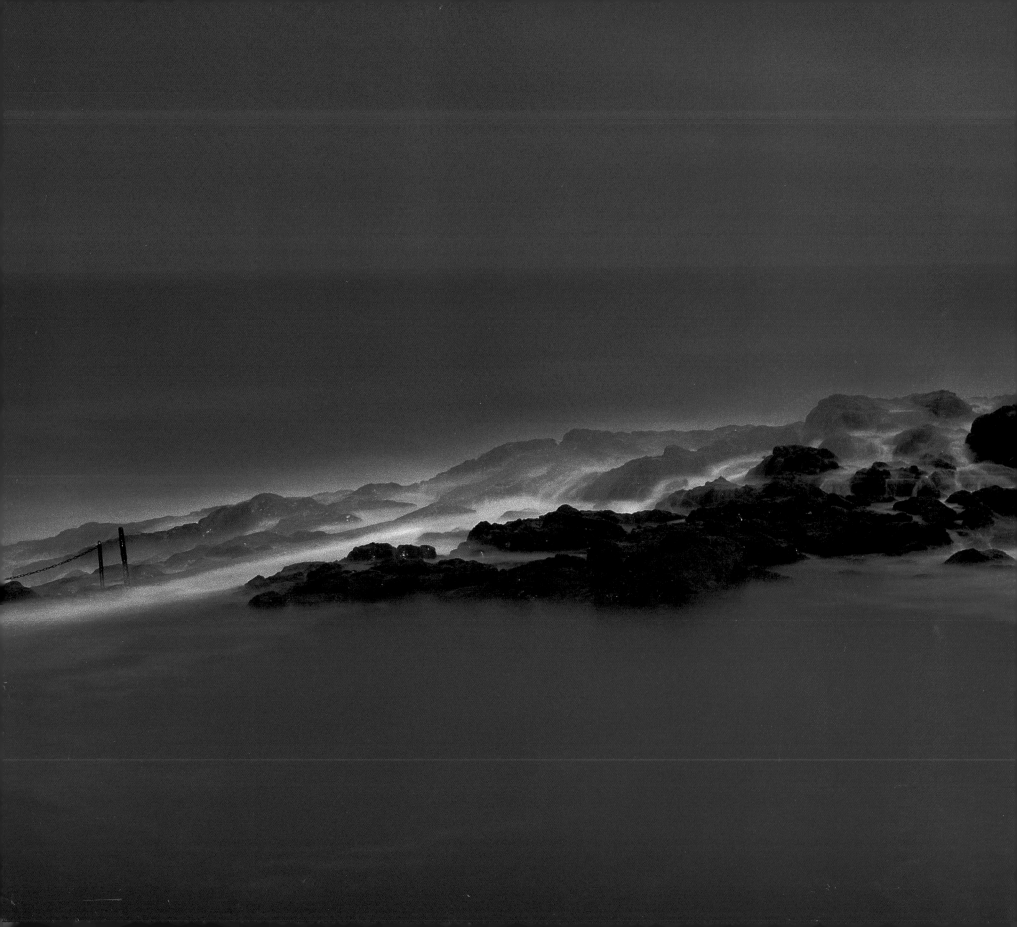

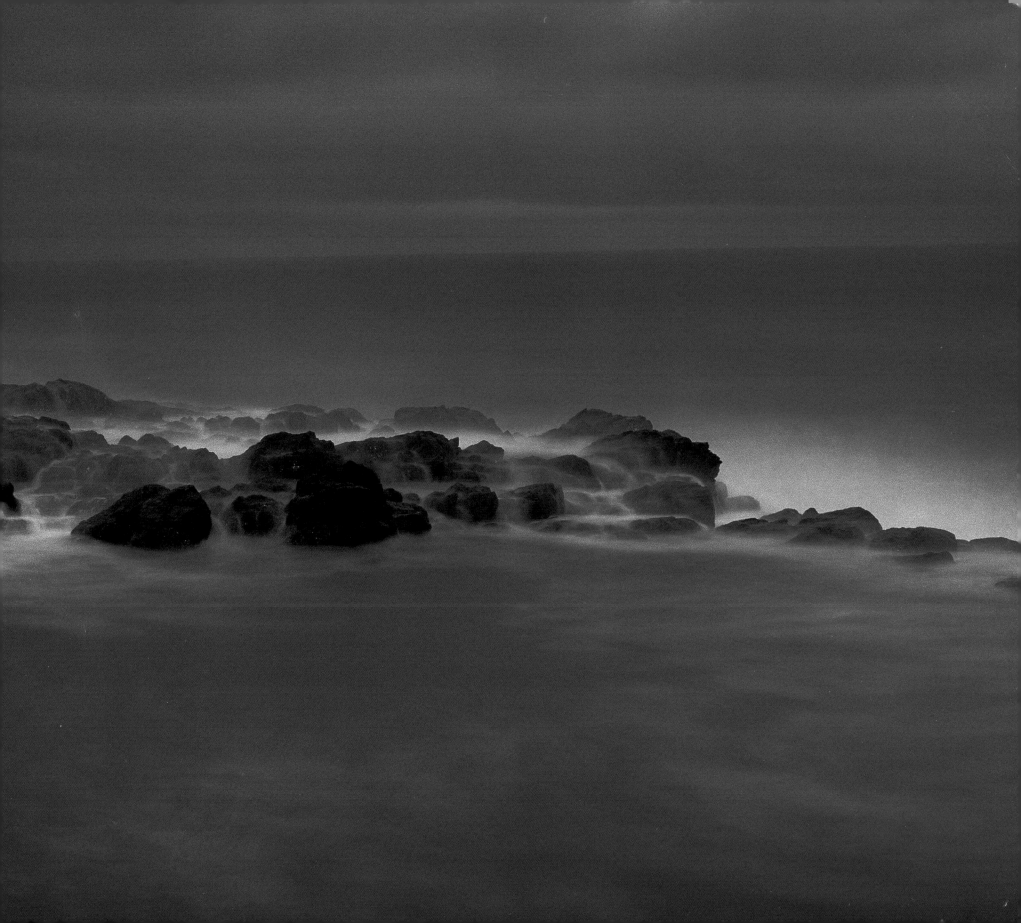

'SENSE OF WONDERMENT'

He's rung to tell me he's been watching a hawk hovering over a tree-lined gully. 'I realise it's a bit like me,' he says thoughtfully. 'I'm a hunter – one hunts for pictures and one is infinitely patient ... As I watched, I thought the bird and I have that in common.'

Richard Woldendorp insists he's hopeless at expressing his feelings about the art of his photography. He says it's hard to find adequate words or, at least, to write it down 'in a way that's more poetic in form'.

'I want to tell a story about the way of looking at things, a sense of wonderment at the beauty of nature,' he tells me, with a hint of impatience in his voice. 'The rhythm in the oceans, the way the wave comes in and fractures, the lace-like beauty of it.' I tell him he's not doing a bad job of being poetic.

People only have to look at his pictures to know what he's talking about, I suggest. 'Unhesitating images', one critic called them, 'simple, clean and harmonious'. He calls himself 'a straight shooter'; he's proud that he has never resorted to fancy photographic techniques, or a clutter of camera equipment, to capture his prey.

Woldendorp is one of those migrant success stories that enrich Australian life. He's now lived here for fifty years. 'Dutch painting contractor wins first and third prizes simultaneously in Australia's richest photo exhibition.' His switch to a photographic career in the late 1950s soon proved fruitful. Since then, he has won a swag of photographic awards, produced more than a dozen books and witnessed his photographs entering most major public and private art collections.

Thousands of words have described the almost elusive qualities that make a Woldendorp picture stand out. Stillness and monumentality in the mid-air portraits of a giant land; flickering moments as a flock of birds flies across a river delta; immutable grandeur as dawn rises over vivid red rocks.

Another great Australian photographer, Max Dupain, has probably put it best. 'With vast red spaces, rippled by dunes and pitted by saltbush, Woldendorp's images could have been made a million years before man,' he observes. In his opinion, Woldendorp has made 'a one-man Herculean effort to show Australia to the Australians'.

Dupain has a way with images and with words. And after we have shared several lively conversations, it's obvious that Woldendorp too possesses a twofold gift for communication. It's just that, while he alone captures the images, he wants someone else to pin his words down on the page. So I have obliged.

VICTORIA LAURIE

Front cover: Red dunes, formed by drift sands unlocked by bushfires, ripple across a tussocky landscape in the Australian desert.

Back cover: Sandbank north of Cairns, Queensland.

Previous page: Black basalt outcrops along the New South Wales coastline, a once-fiery lava flow frozen amid the waves.

COASTS

The speck of a small plane is moving lazily over the jagged coastline of Australia. Every so often the plane lands and a sole occupant alights to wander along the shore.

Along the mighty length of this coastline Woldendorp can spot a million pictures. There's the energy of king tides and the oozing sprawl of mudflats, elegant clusters of granite rocks thrusting from calm seas and the miniscule beauty of polyps exposed at low tide.

Every subject is an exercise in learning to see, he says. 'Like looking at two estuaries from the air and seeing how, in Western Australia, traces of the brown tannin of the forest is always in the river.'

His eye is instinctively drawn to the contrast between the dark, almost sinister waters of the inland estuary as it attempts to break through the sandbar, and the white radiance of ocean waves beyond. 'You've got a barrier that's far enough inland not to be coloured by the sea, just washed, caressed occasionally by it.'

Other barriers in nature have attracted Woldendorp's camera eye. Tropical mangroves have an unnatural intensity and a green-blue hue; rich sanctuaries for marine life, they form a ribbon between land and deep ocean. It's as if a child has taken a coloured pencil and outlined every edge.

Close up, mangroves are instructive if you're with the right person, Woldendorp tells me. It's one of the secrets of his success, and the source of immense pleasure – being led into unfamiliar territory and taught to really look.

Take the case of Toby Thomas, a friend from the Bardi community in the coastal Kimberley region of Western Australia. He knows how to select mangrove trees for raft building, and Woldendorp was once sent north to document his skill. 'It was a wonderful experience – you just surrendered yourself to the knowledge of this man. He'd say, "You don't move now because the tide is against us". He knew where to find good water, and he went around with a spear looking for turtle eggs in the sand."

'I couldn't walk through the mangroves because of the spikes growing up through the mud, but Toby had no trouble. He said one in twenty-five trees – but only one – was like balsa wood, so it would float. But we had to take the bark off immediately or you couldn't ever get it off.'

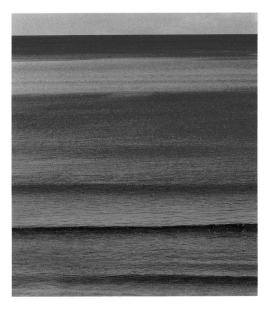

As we pore over pictures, it's clear Woldendorp is especially drawn to the tidal landscapes of Australia's north-west, fluid areas dominated by the force of eight-metre tides. He likes the 'no-man's land' of mud expanses, 'Where sea water drains in and out – it's quite far inland, but it's still a tidal landscape.

'I'm fascinated by the play of light over wet and dry – it shows off the structure of things, what they're made of. It's so lovely to see a huge flood plain, the complexity of the water flow and how it runs every which way.'

Sometimes the subtlety of nature's palette is captured so exquisitely by Woldendorp that you want to cry out. Often it reveals itself where sea meets land, when fierce tidal movements fold and mix clean pale sands into the banks of red dunes. Or when blue-and-white cloud swirls are reflected on the still surface of yellow-green shoals.

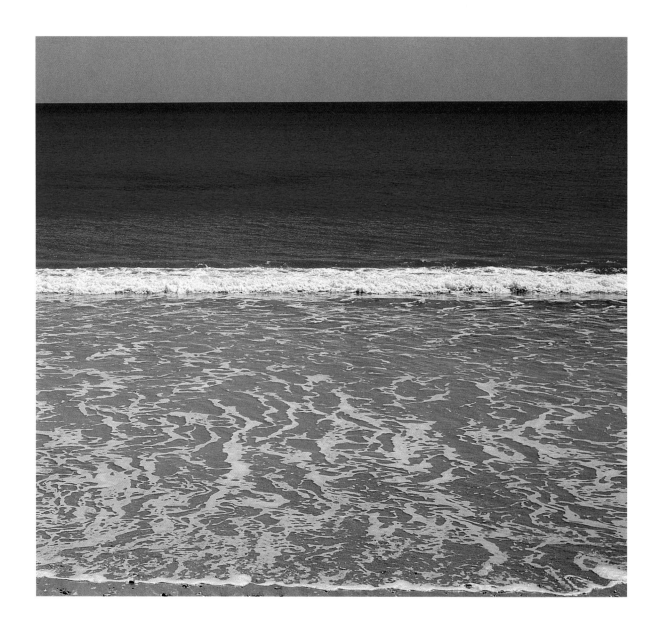

Frothy lace and patchwork quilt. Along the seashore, nature creates patterns
for our eyes' delight. Broome and Burrup Peninsula, Western Australia.

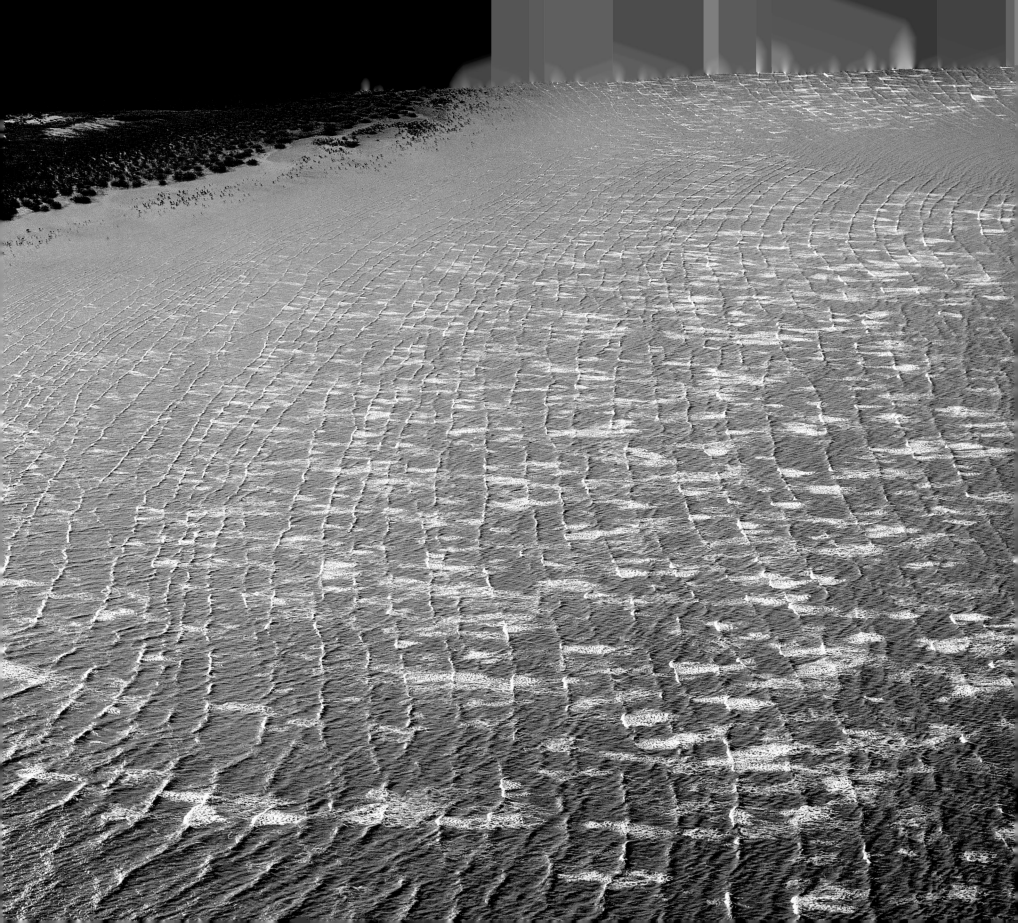

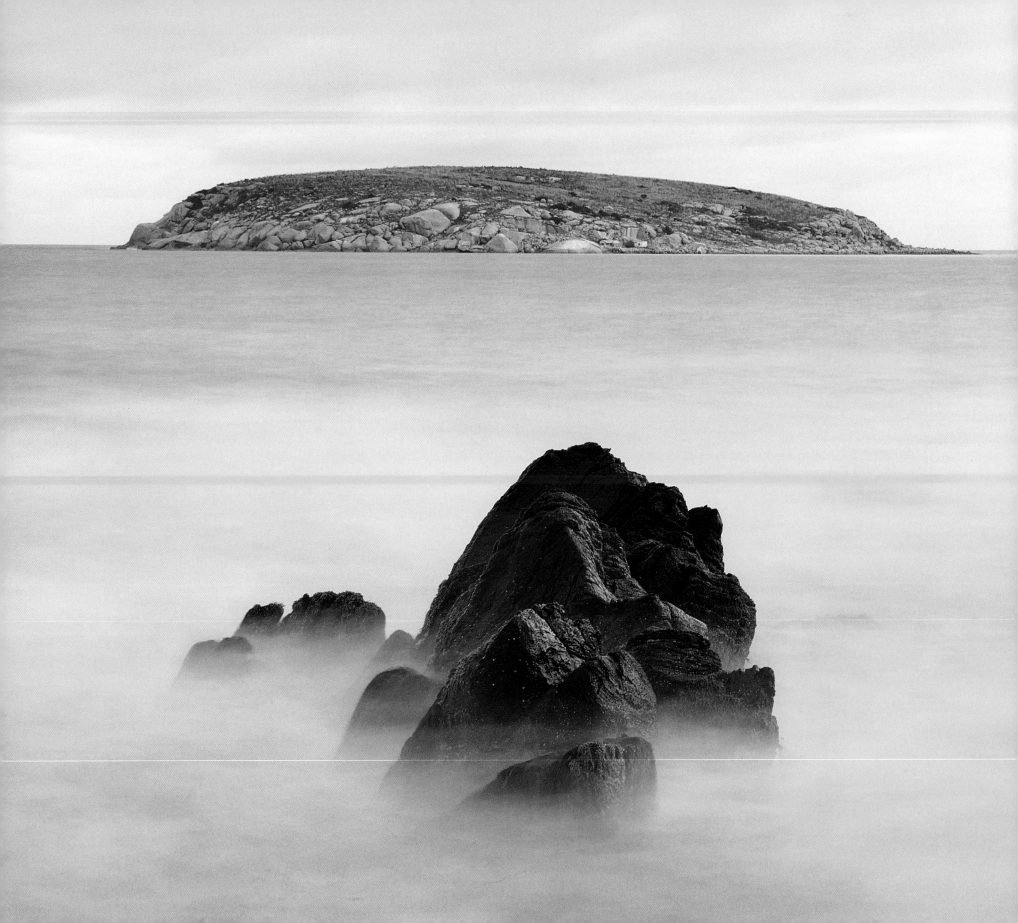

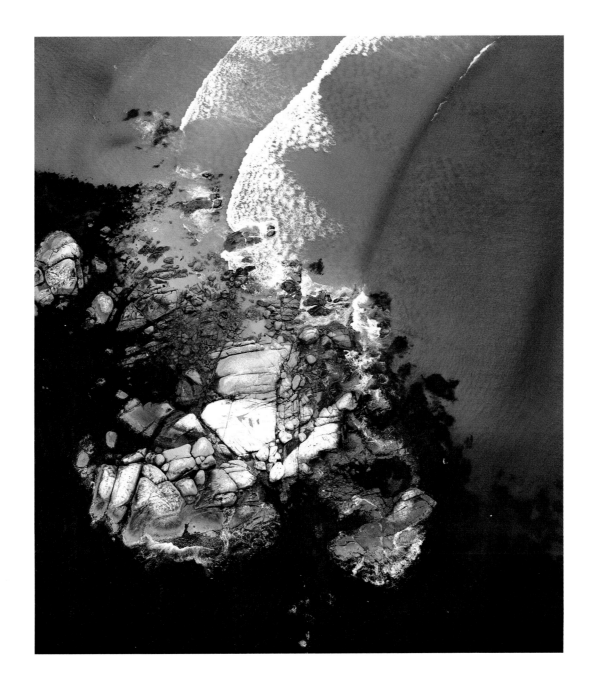

These sections of Granite Island rise like brown blisters from the sea,
eroded by time and waves into smooth domes. Victor Harbour, South Australia.

Opposite: Near Orbost, Victoria, basalt rocks thrust upward from the ocean floor.
On the horizon, the rounded contour of a granite monolith.

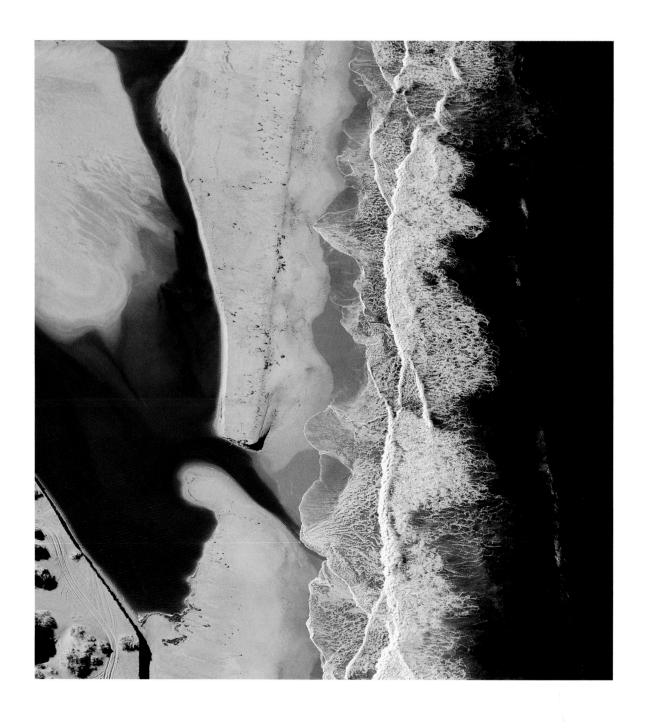

Aerial abstracts formed by the meeting of estuary and open sea — tannin-stained rivers carve a channel into the ocean at Moore River and at the mouth of the Warren River, Western Australia.

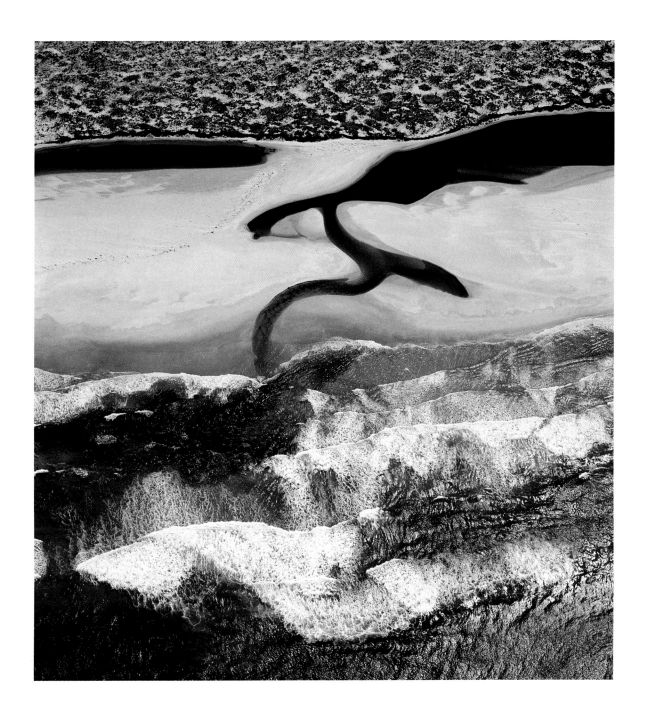

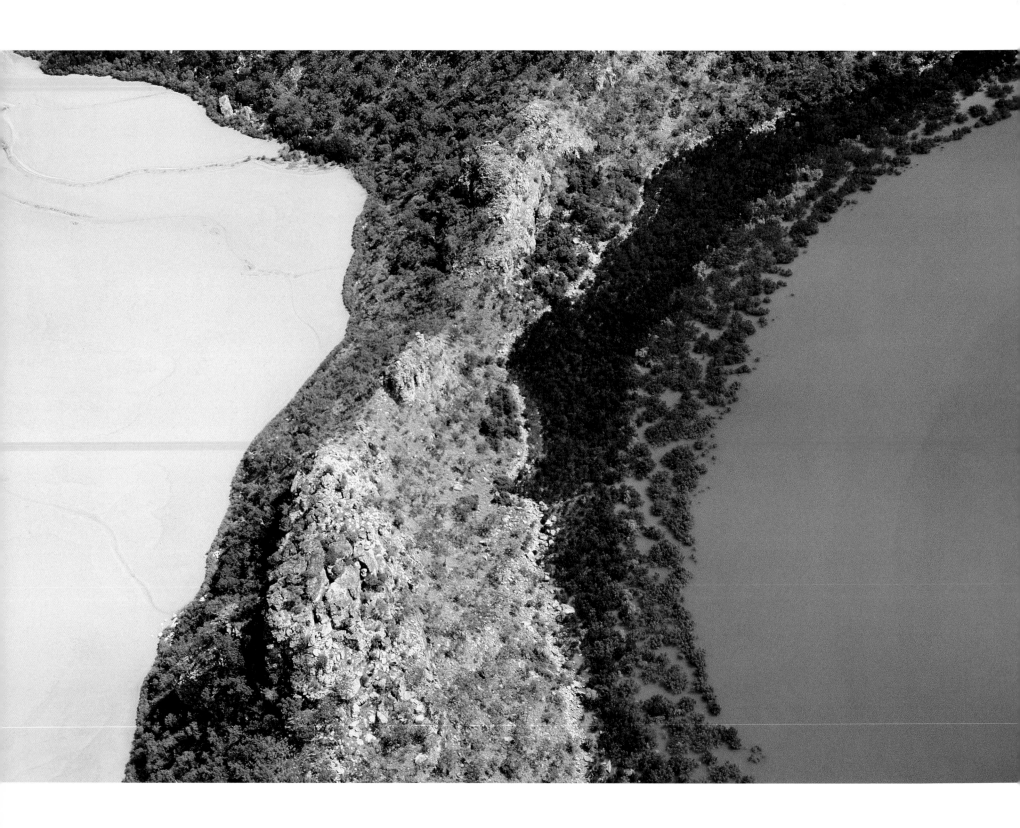

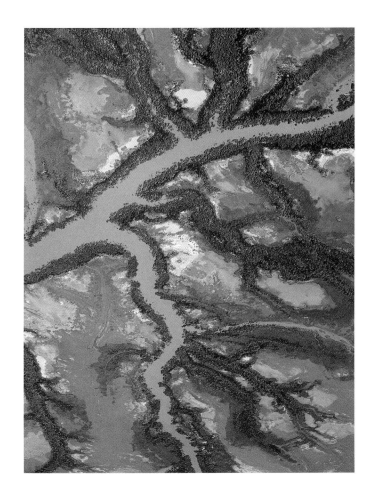

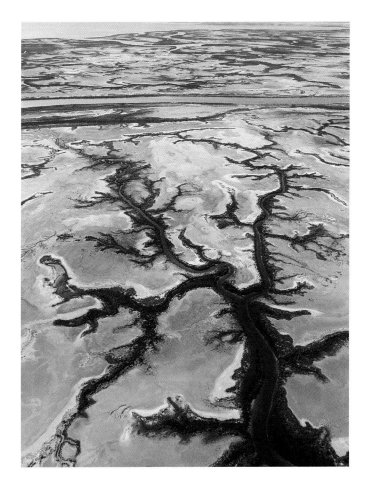

Two Northern Territory estuarine mudflats, Victoria (left) and McArthur
(right). The pink-hued estuary is fed from iron-red laterite country, while
the khaki mudflats emanate from pale sandstone and granite catchments.

Opposite: A hard-rock mountain range leads down to a multi-hued fringe of mangroves
with their roots in warm Indian Ocean shallows. Kimberley region, Western Australia.

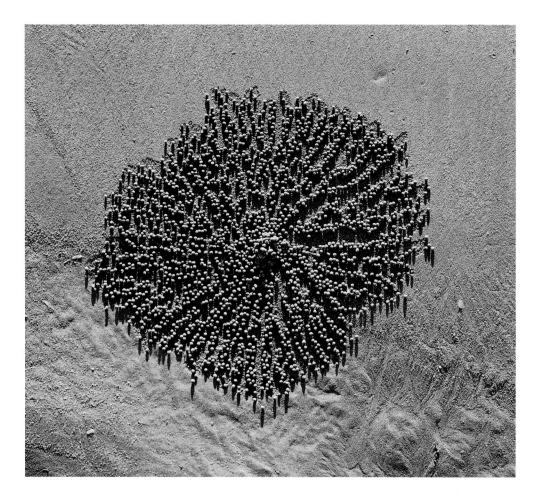
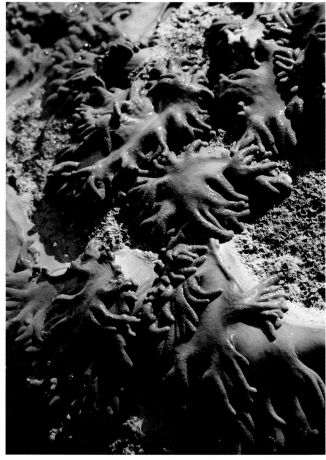

Left: Low tide treasures. Resembling a delicate lace doily, a crab's
handiwork of sand balls on a tropical beach in Broome, Western Australia.

Right: Polyp-like seaweed exposed by ebbing tides on Sunday Island, King Sound, Western Australia.

Opposite: Majestic views — of mud, carried slowly by the Fitzroy and Meda Rivers
and washed across the landscape by awesome eight-metre tides at King Sound, near Derby, Western Australia.

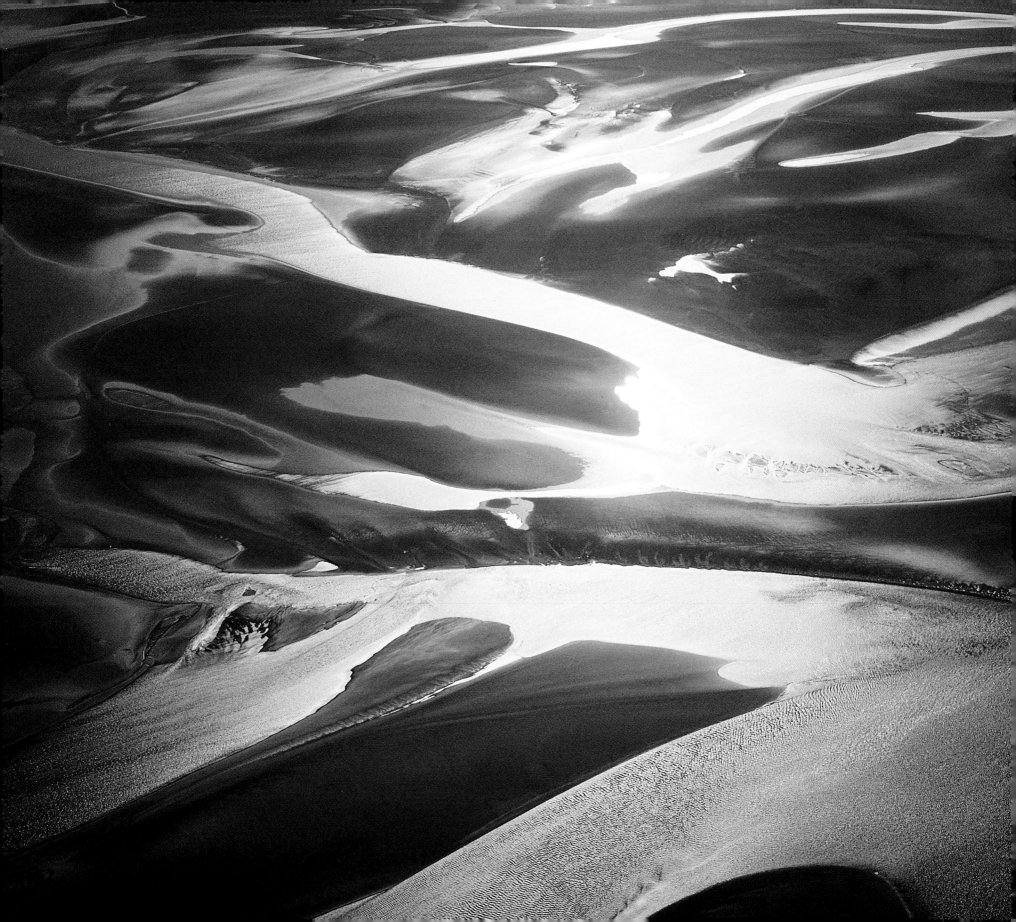

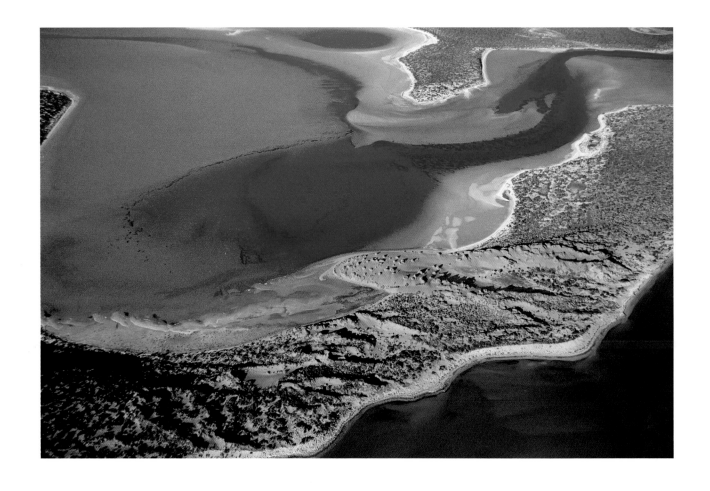

An ancient limestone ridge cutting Big Lagoon from Freycinet Reach, Shark Bay, Western Australia.

Opposite: Fierce tidal movements behind Curtis Island, central Queensland, fold and pummel
the clean-washed sands, mixing them with red sands from nearby Cape Curtis.

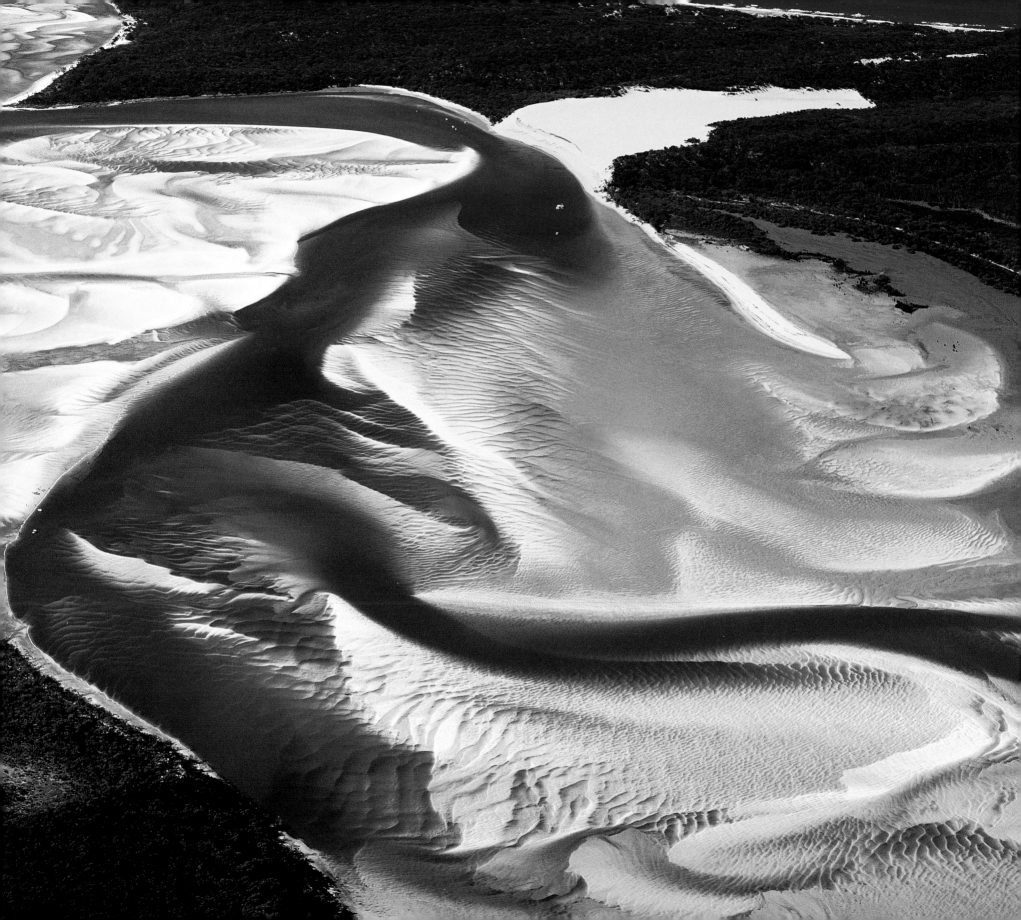

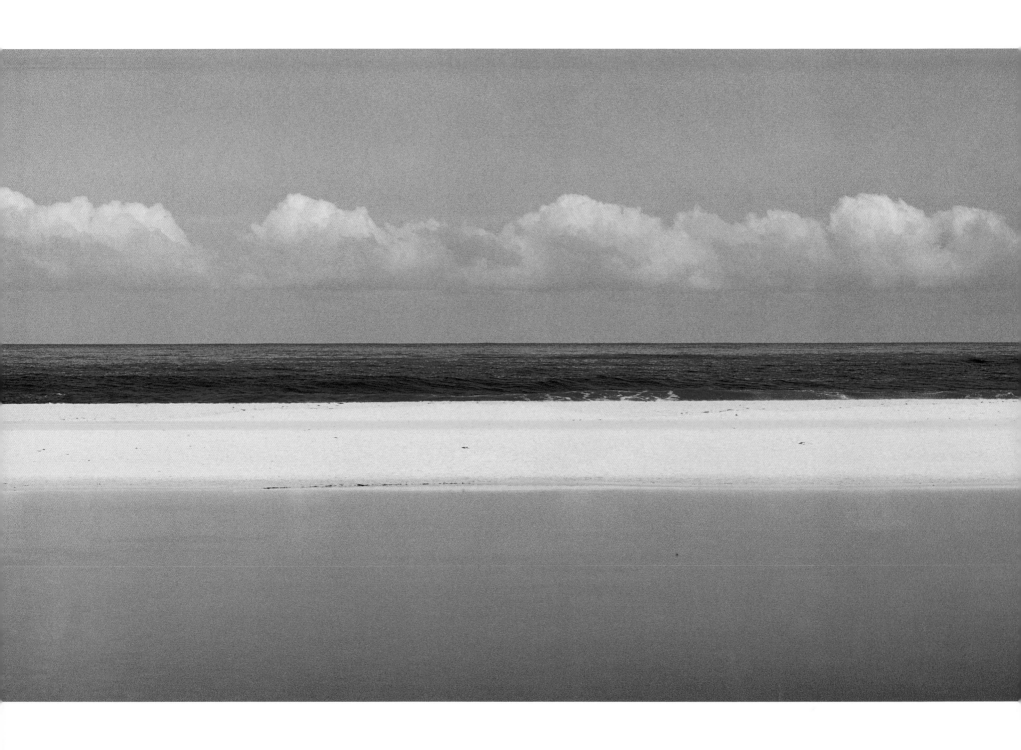

As elemental as an abstract painting — sandbar, sea and cloudy sky at Margaret River, Western Australia.

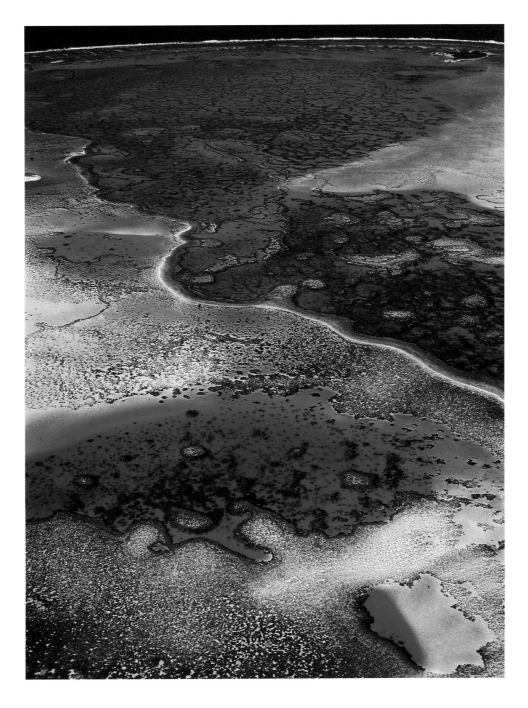

Jewel-like patches of coral at Wistari Reef, part of the Capricorn Group near Heron Island,
Queensland. A typical scene in the Great Barrier Reef, these patch reefs are built
on ancient hills that were flooded by rising sea levels in the post-ice age.

THE GREAT INLAND

Dot, dot, dot ... identical-looking eucalypts grow at even intervals across the Pincombe Range, east of Kununurra, in a dry-season landscape that waits for the cattlemen to move in and set fire to tufty spear grass.

The speck, with its mosquito-like engine drone, has moved inland over thousands of kilometres of desert. 'It's amazing how impressive nothingness can be,' observes Woldendorp.

The desert is the most quintessential Australian heartland. 'But it is a red heart, not a dead heart,' Woldendorp's naturalist friend Alan Fox has often reminded him. Fox is the man to whom Woldendorp turns for scientific information about what he has seen and captured on film.

'The Australian desert is home to mulga, mallee, desert bloodwoods, spinifex, daisy and pea plants, and hundreds of other species,' explains Fox. Then there are the animals — red kangaroos, mala hare wallabies, marsupial moles, bilbies, giant perentie lizards, sand goannas and dragons, budgerigars, kestrels, crows and crimson chats. 'How can we call the desert empty,' Fox asks?

As I stare at each magnificent image, I'm pondering a more mundane question: how does Woldendorp capture so confidently the right shot as he flies in a fixed-wing aircraft, a thousand feet above ground, at an old-fashioned hundred miles an hour?

In more grandiose articles about him, Woldendorp is likened to 'an aerial version of Ansell Adams', America's most revered landscape photographer of the twentieth century. Airborne is the way Woldendorp likes it best. 'It's been exciting — still is today — to fly over land and look at the evolution, the structure, the form, what I call "the reason for",' says the photographer.

He relies on a pilot's local knowledge to steer him towards interesting features of an area. 'I can then have some control over the pilot unless there's a problem with the weather or fuel's running out.' He has an intuitive feel for curious panoramas and says he can anticipate scenes coming up, like the precise moment when a road will fall corner to corner across the picture.

But what if the plane gets to a perfect midair vantage point and the camera jams? Or the light is all wrong or the plane judders? It's hardly possible to say, 'No, back up! Now nosedive a little, stop!' He can hardly order a mountain to move a little to the left.

'Because the landscape is so far away, you can take fairly slow exposures,' Woldendorp explains. 'The plane does bounce up and down in updrafts or winds, but as the air cools towards evening it provides the most beautiful conditions.'

He picks up an image from typical Queensland dry country, shot as dusk closed in. 'It's not often I can take photographs from the air at a thirtieth of a second, but sometimes the conditions are so still,' he says pleasurably, as if reliving that magic moment.

'The pilot just flies straight on and there's no movement. The plane is welltuned so there's minimum vibration and you don't lean on any part of the plane. You just open the window and it's still, just like sitting here now.'

Why has he taken to the air with such regularity, especially in recent decades? One of his first books was *The Hidden Face of Australia*, his first serious attempt to present the Australian landscape as being worthy of intense artistic study. It was then he realised he needed a different vantage point from which to observe this uncompromisingly flat continent.

'Australia has the most worn-down landscape, and the aerial perspective gives it a truer and more informative picture,' he explains. 'If I walk I'm bound by the limitations of my height from the ground and I can't appreciate the whole landscape. I go over the next hill and it's the same. I get up in the air and I can see the whole magnificence of the landscape. It comes up to me and it reveals its continuity and its strength.'

'And often the only way to see it is from the air — nobody drives here,' he says, gesturing at a picture of an unmarked desert, 'there are no roads.'

Luckily for him, the right elements fell into place at precisely the time he needed them — cameras that could photograph at high speed, aircraft hire that became available at the right price. And colour film became sufficiently reliable and durable. 'I'm lucky — in my lifetime the whole thing came together! Plus I had the bonus of the right country to do it in.'

'The view from the air is so unpredictable — I don't always know what I'm going to see. Then for one moment the landscape and I come together and I see something unique, something that is mine alone.'

Spinifex grows outward from the parent plant, creating a crinkly pattern that — from the air — bears an uncanny likeness to an Aboriginal painting.

Opposite: Dry season landscape in the Pincombe Range, east of Kununurra, Western Australia, before the midyear ritual in which cattlemen set fire to the spear grass. Identical eucalypts dot the landscape, growing at neat intervals.

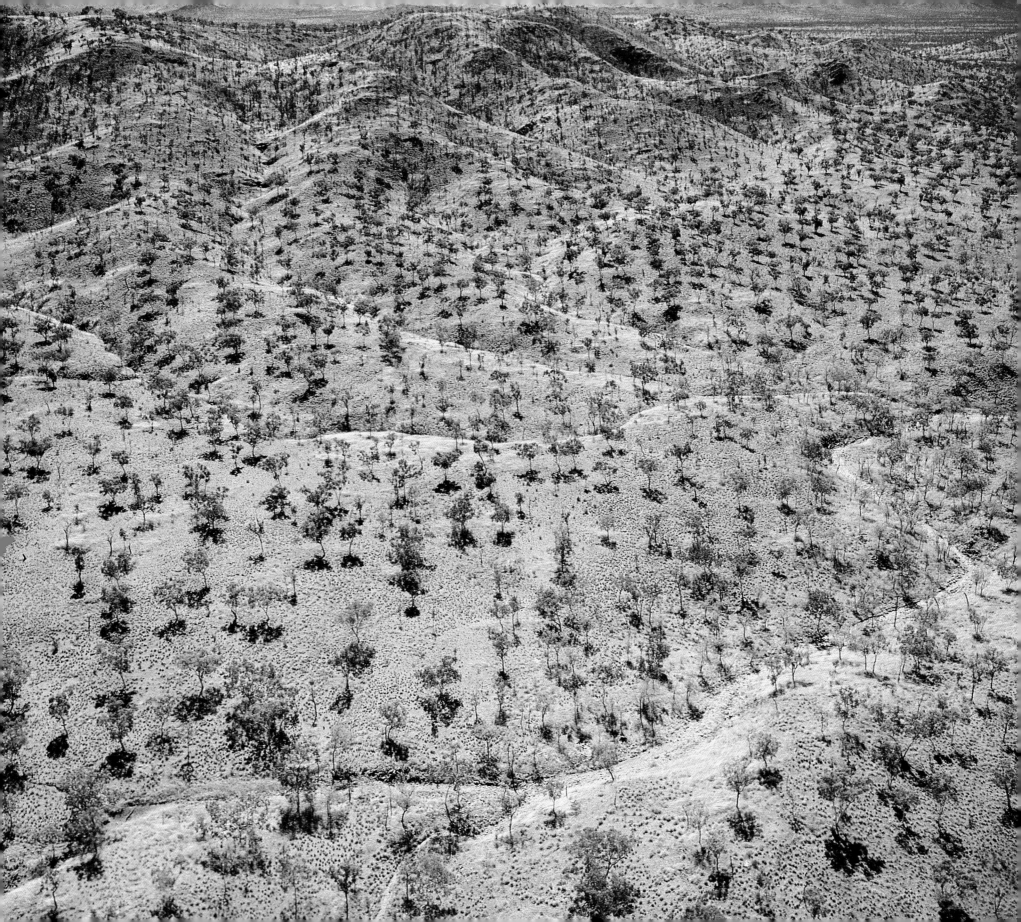

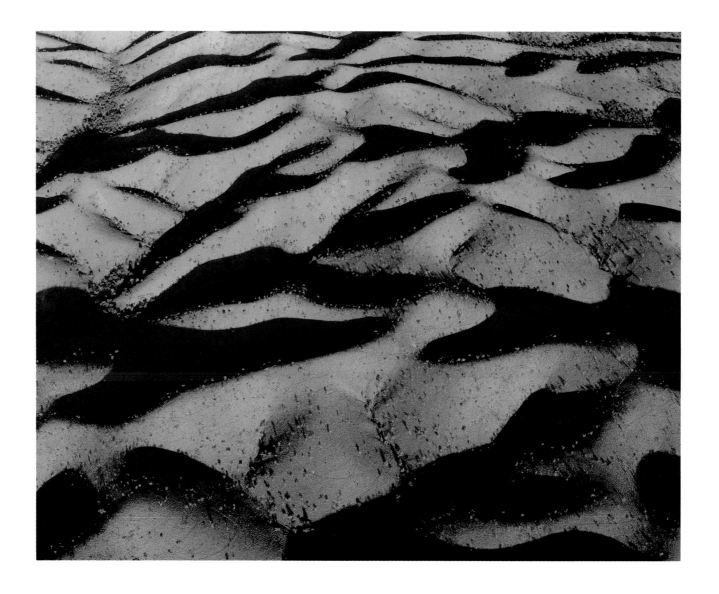

Soft slopes and dark shadows on the edge of Missionary Plain, south of the West Macdonnell Ranges, Northern Territory.
Wary inhabitants of this spinifex terrain include euro wallabies and wedge-tailed eagles.

Opposite: Summer clouds cast sprawling shadows over the sand plains of Australia's driest country, the Simpson Desert.

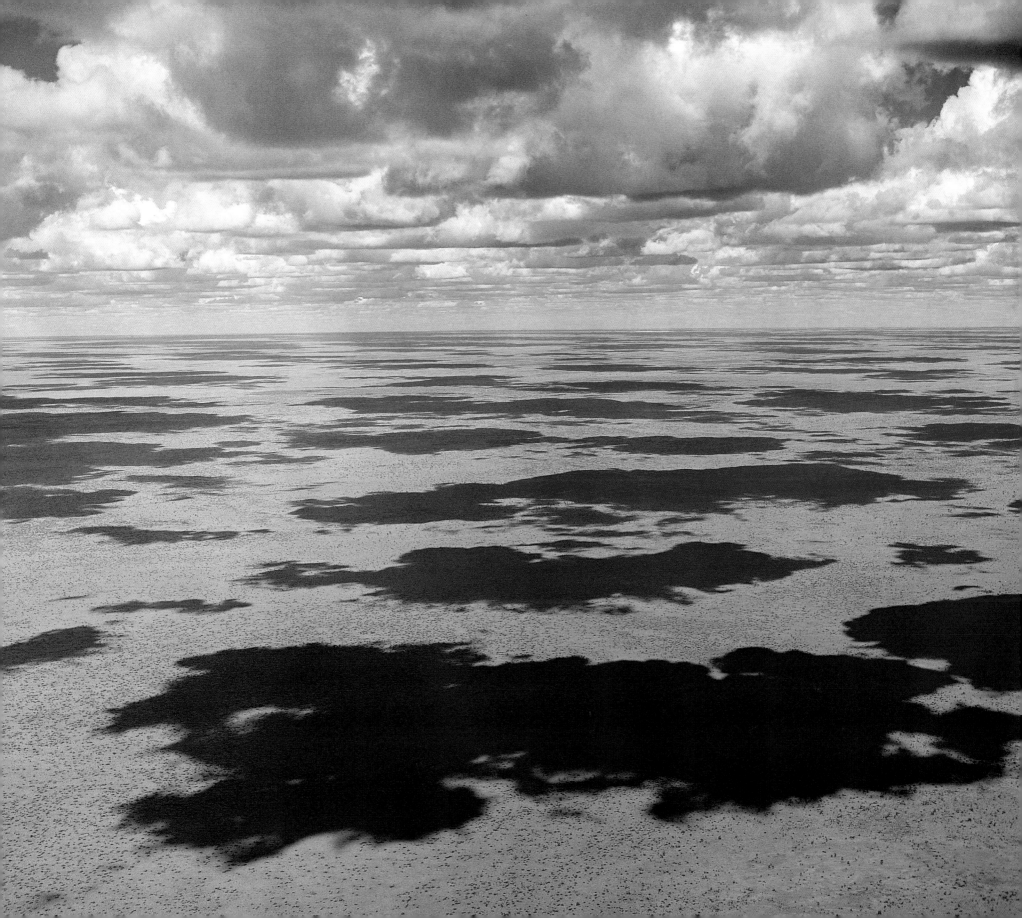

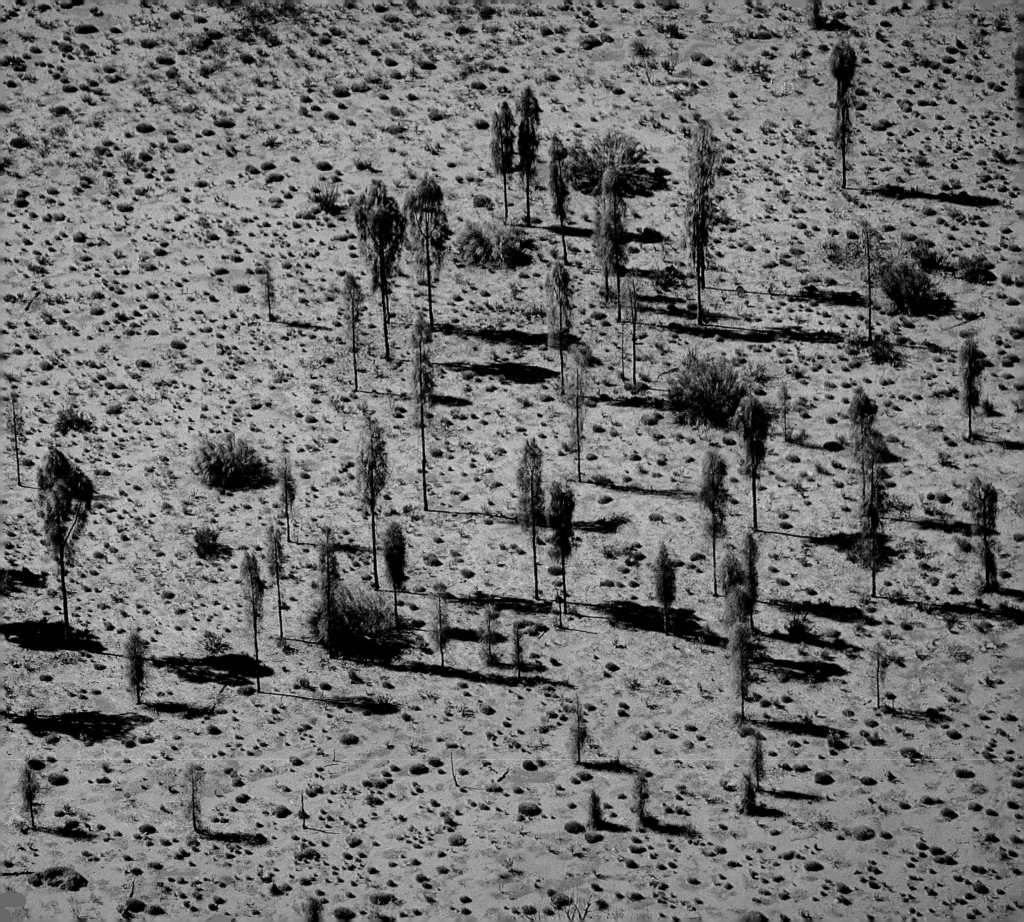

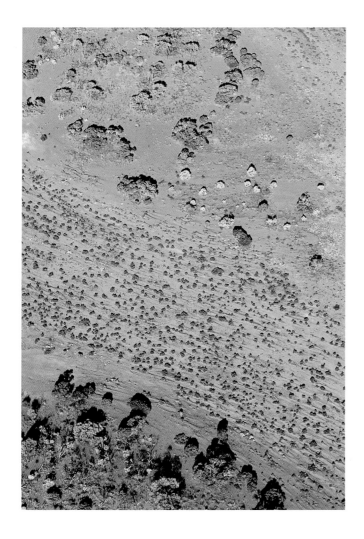

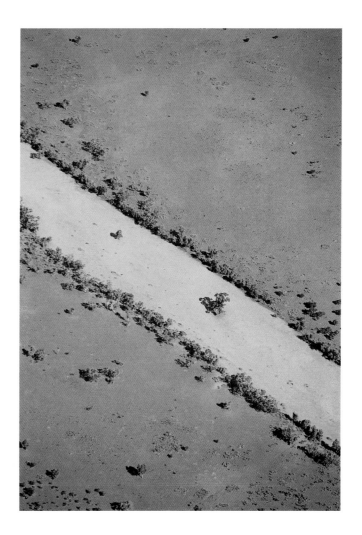

Left: An incongruously named flood plain, parched in summer but draining into the Murchison River, Western Australia, after a downpour of rain.

Right: A dry river in Central Australia waiting for the seasonal deluge — if it comes.

Opposite: Desert oaks stand to attention near Uluru, Central Australia, Northern Territory.

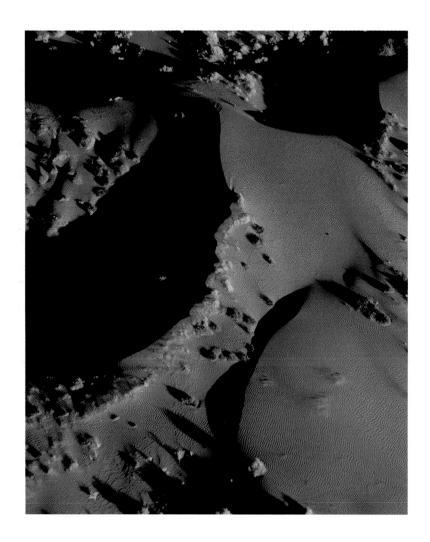
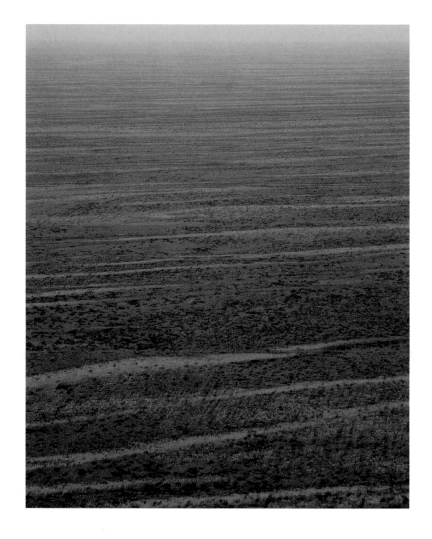

Left: Cardinal-red dunes in the Strzelecki Desert, South Australia, where light conditions offer spectacular colour changes throughout the day.

Right: A more distant view — streaks of sand dunes, interspersed by mulga vegetation, are touched by the rising sun.

Opposite: The uniform distribution of growth through this dune landscape is unique to the southern end of the Victoria Desert.

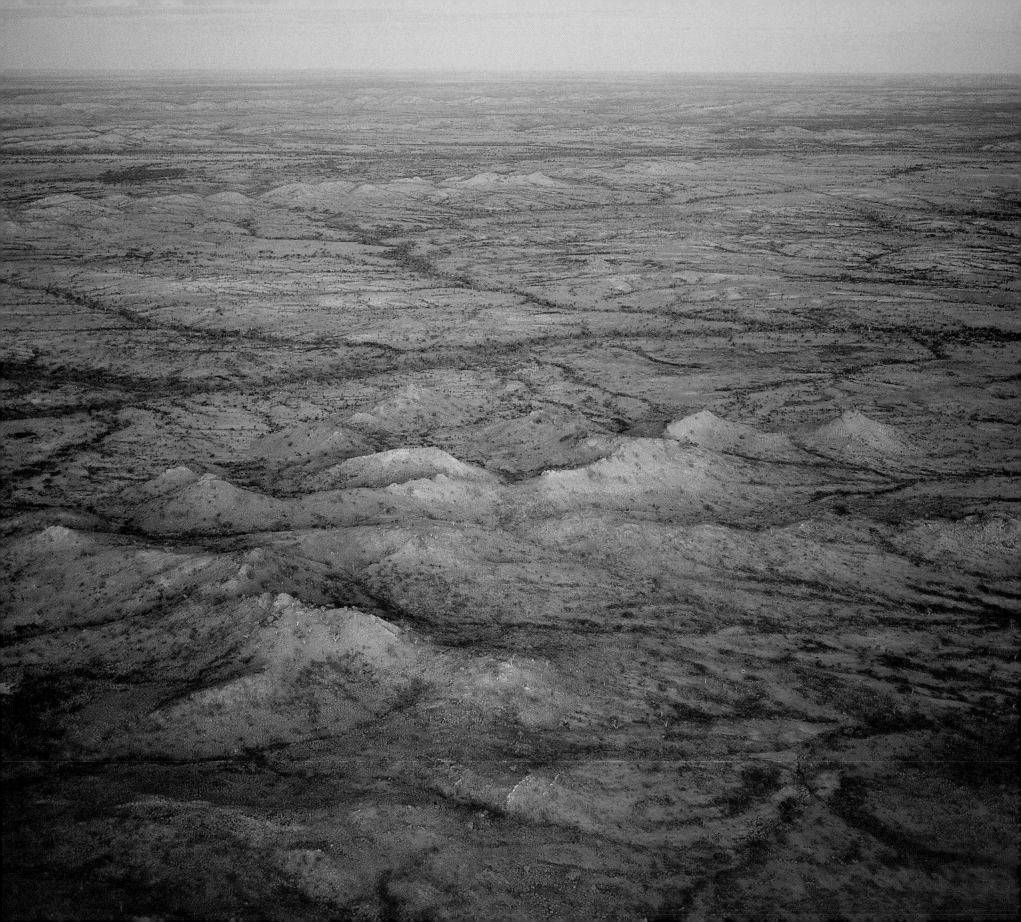

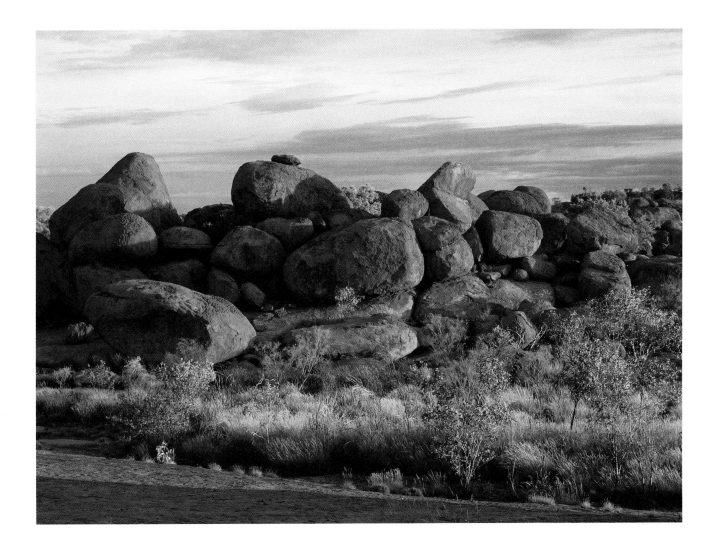

Granite boulders bathed in red light from the setting sun — a surreal-looking habitat for marsupials like the shy euro wallaby. Chichester Range, Western Australia.

Opposite: An ancient, well-worn landscape between Dajarra and Mount Isa, Queensland. Desert bloodwoods, coolabahs and ghost gums grow on shallow soils in these hills — beneath them, one of the world's richest copper deposits was found at Mount Isa.

SALT LAKES

'I've been accused of making everything look pretty, but I think there's more to it than that,' says Woldendorp suddenly, during one conversation conducted over cups of coffee and piles of glossy prints.

We're looking at the terrible beauty of salt lakes, deadly white islands scattered across the south-west corner of the continent. They look like strands of pearls on a broken necklace, strung loosely across the land. How can Australia's worst environmental threat look so beautiful from the air?

'I'm trying to convey what's there, and I'm trying to convey this through strong composition and an element of surprise. Something that makes people want to stop for a moment and say "Isn't this interesting?" I become the communicator and I think that has great value.'

Woldendorp admits that salt lakes are 'my hobby — and you must remember that most of them are natural.' It's true — the pearly white circles near Esperance in Western Australia are natural phenomena, caused when inland oceans dried up aeons ago and left great pans of salt.

But Woldendorp's pictures also record the man-made activities that have exacerbated the problem — land stripped bare of native vegetation that once drank up underground water with their deep roots and prevented salt from rising to the surface. Many native species have learned to withstand centuries of natural salt accumulates in the soil — melaleucas, saltbushes, bluebushes, burr bushes, samphire and many eucalypt types.

Woldendorp arrived in Western Australia at a time when land owners were being urged to clear land at a rate of a million acres a year. 'They did it — they did it in South Australia too, and we thought, "aren't we clever?" A generation later we're trying to rectify the mistakes, yet in the 1960s the effect of salinity was already known.

'Our salt problem is a really big one,' he says, 'and I think that if we'd appreciated the land, from whatever point of view, we'd have trod more lightly. I think I play a little role in showing the beauty that we should always appreciate. If we have no appreciation it makes it a hell of a lot easier to destroy.'

In his youth, he tells me, he yearned to be a landscape painter, 'But after the war, certain things weren't possible and I trained in commercial art. My daughter is now a commercial artist too. My other daughter is an environmental scientist and a third has children and works with me.'

He thinks everyone has some sort of talent, 'And the more you realise what your creative medium is, it's worthwhile specialising in it.' Having abandoned his desire to paint, he has nevertheless thought a lot about the relationship between painting and photography.

'The element of abstraction that's in my work is only acceptable because painters first taught us how to appreciate sheer abstract qualities. We don't say, "Oh, I can't see the boat or the people." We can appreciate a landscape as like a Mondrian or de Kooning painting.

'Someone said I photograph with a painterly eye,' he adds. 'I rather like that.'

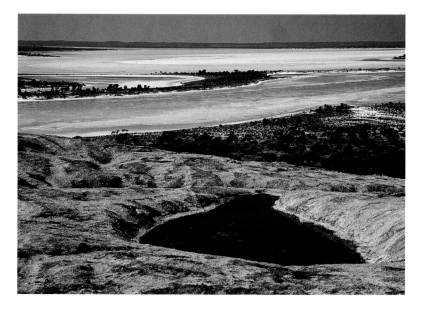

View from Baladjie Rock overlooking its namesake lake. One of the great palaeo-rivers of Western Australia, millions of years ago it was a major river until drifting sands stifled the flow.

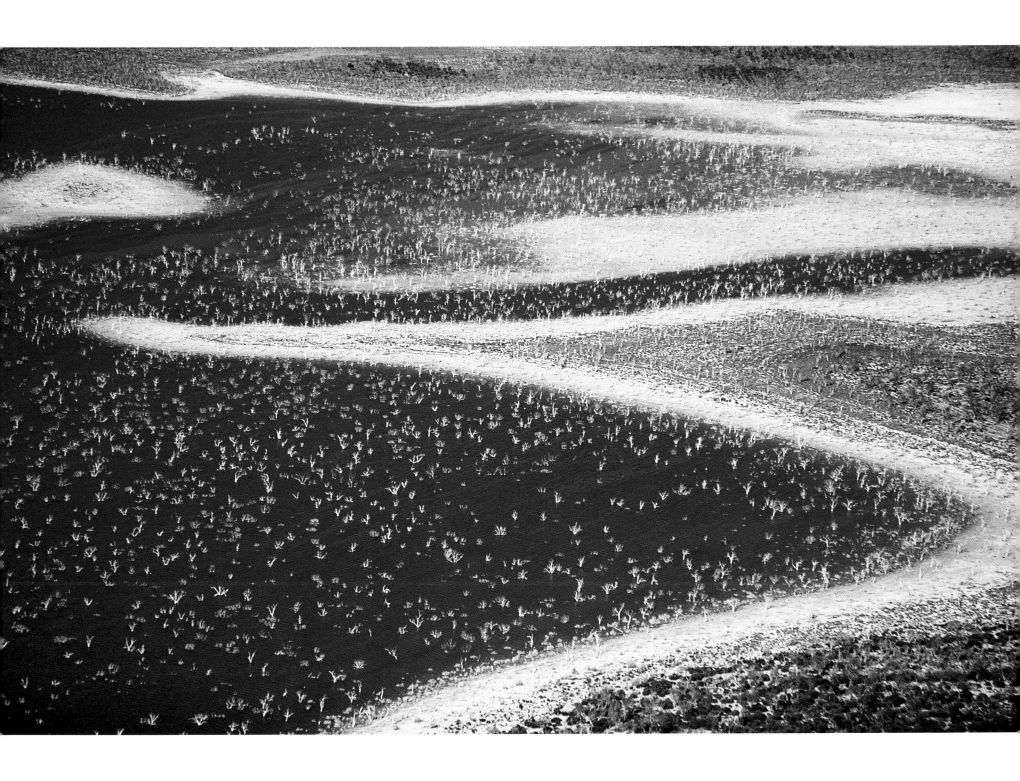

This lake in the middle of the Nullarbor Plain is a result of Cyclone Alby which came from the Leonora region via Ponton Creek, Western Australia after an exceptionally heavy downpour. The combination of water and salt killed the trees. It may be another fifty to a hundred years before this happens again.

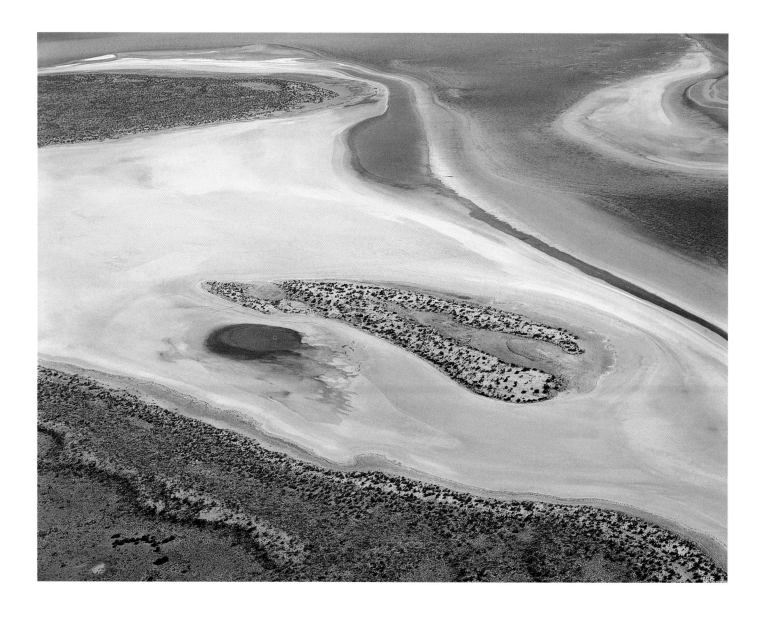

At Lake Amadeus, north of Uluru, Northern Territory, a sand dune is marooned by salt. Aeons ago, this was the forested bank of the Finke River, but today the lake is fed by seepages from underground aquifers many thousands of years old.

Opposite: Dune ridges, now islands jutting from the surface of Lake Austin, south of Cue, Western Australia.
Great pans of salt left by nature. When vast river systems dried out, dune barriers were windpropelled across the riverbed at intervals to create massive chains of linear salt lakes.

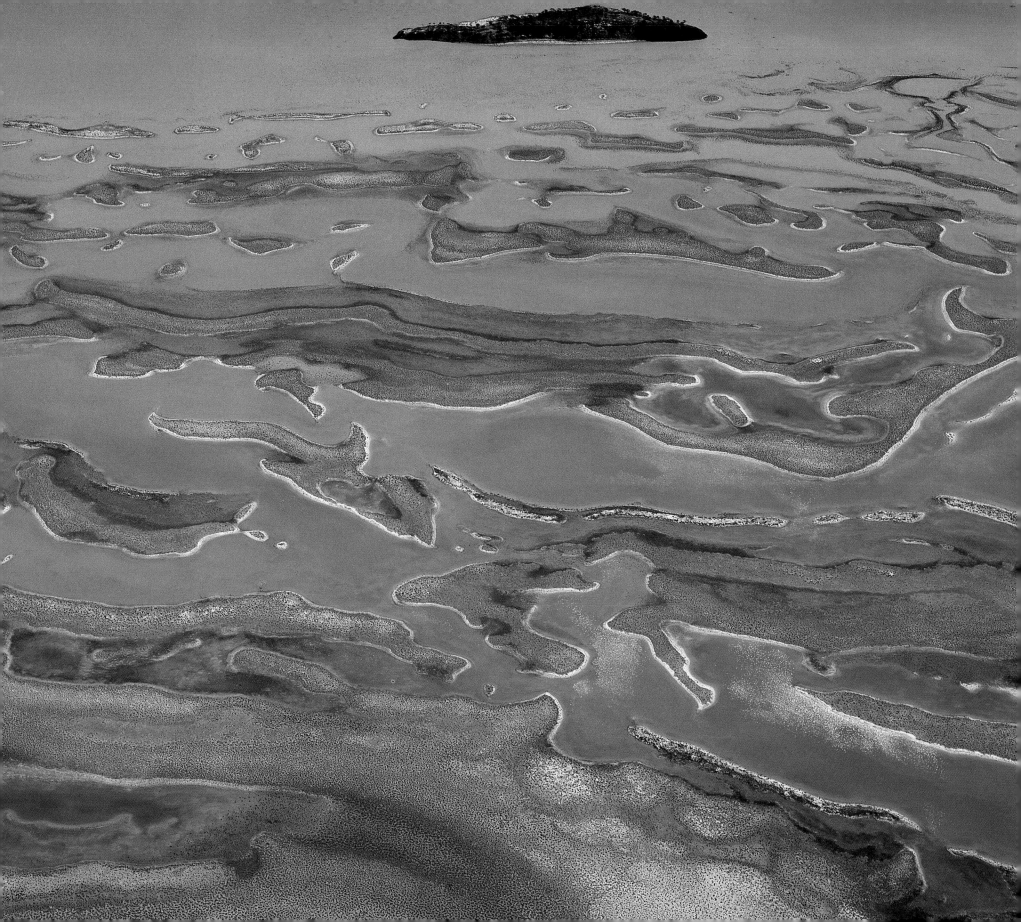

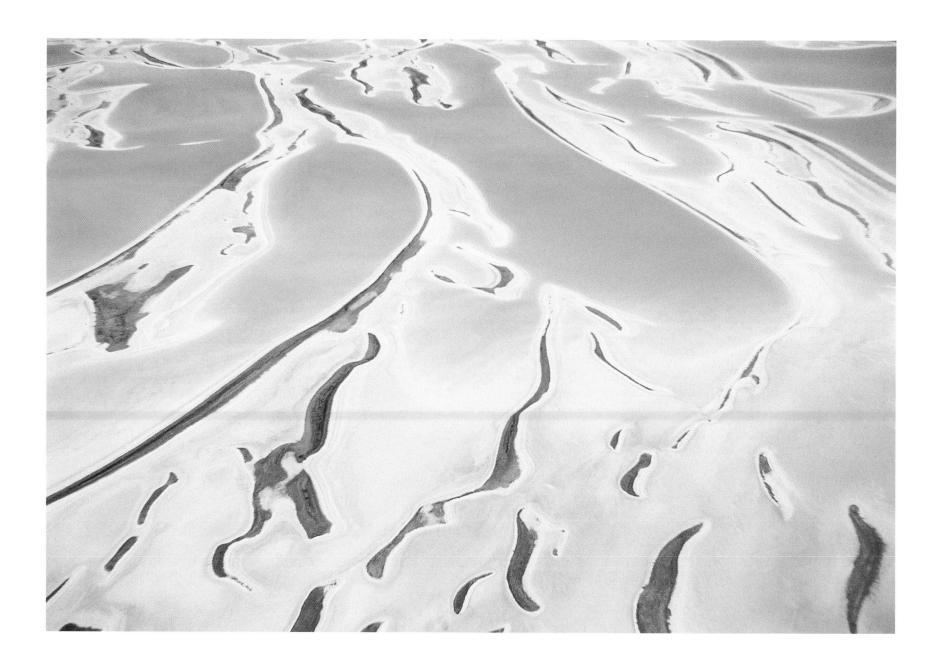

Lake Dumbleyung, in the wheatbelt region of Western Australia.

Opposite: Lake Grace is part of an extensive salt lake system that eventually enters the sea at Bremer Bay, Western Australia.

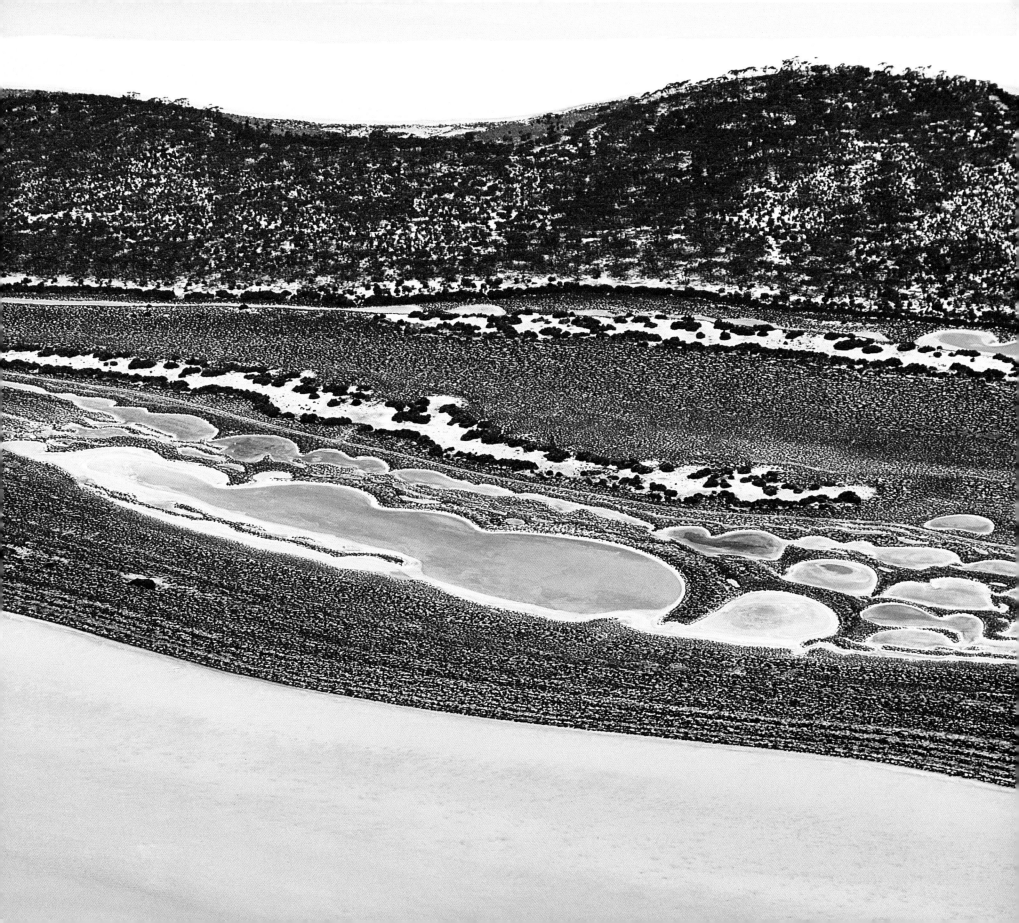

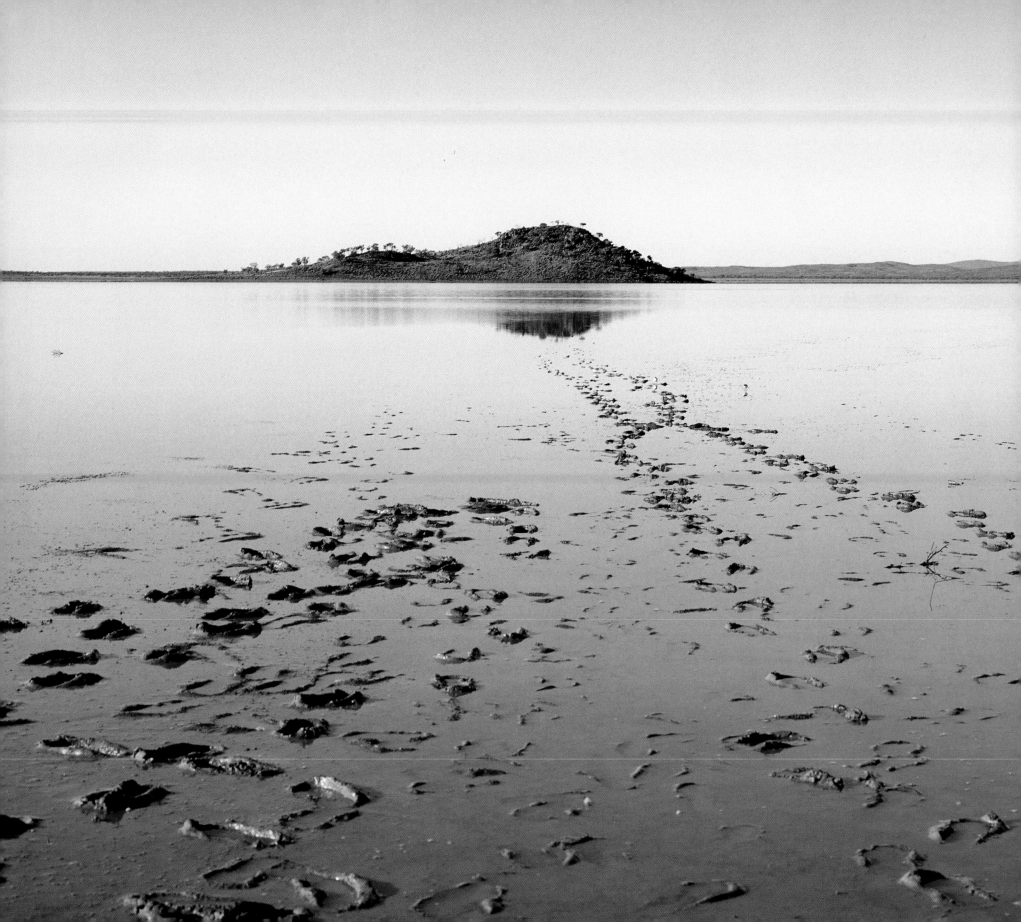

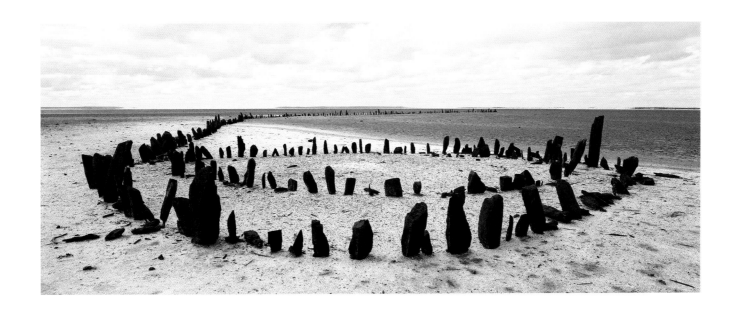

An ancient Aboriginal landmark on Lake Moore, near Paynes Find, Western Australia.

Opposite: Footprints of an inquisitive traveller walking to an island in Mongers
Lake, a remarkable 170km-long stretch of water north of Wubin, Western Australia.

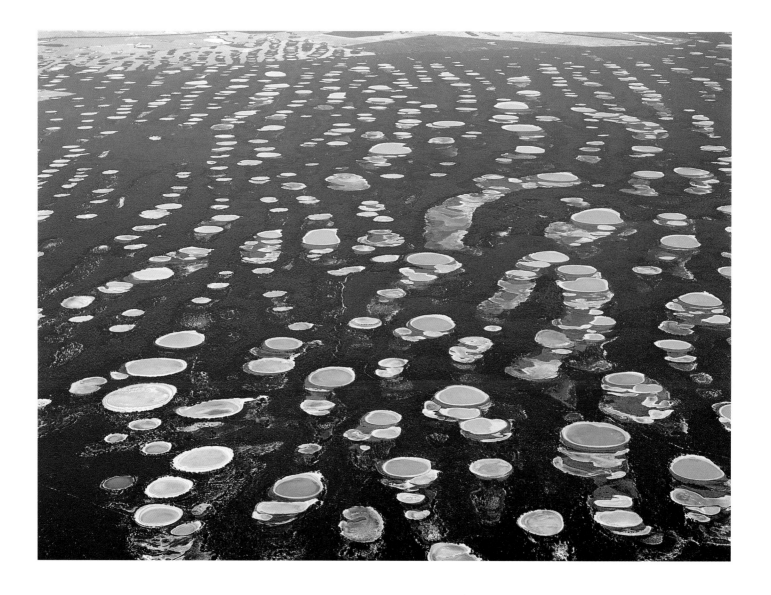

Like scattered strings of pearls, these linear salt lakes north-east of Esperance, Western Australia, are natural. Over time, native plants learned to lock in much of the salt — until humans came along and started clearing vegetation.

Opposite: A smooth, freckled skin over the earth, the surface of Lake Moore in the dry season. Near Paynes Find, Western Australia.

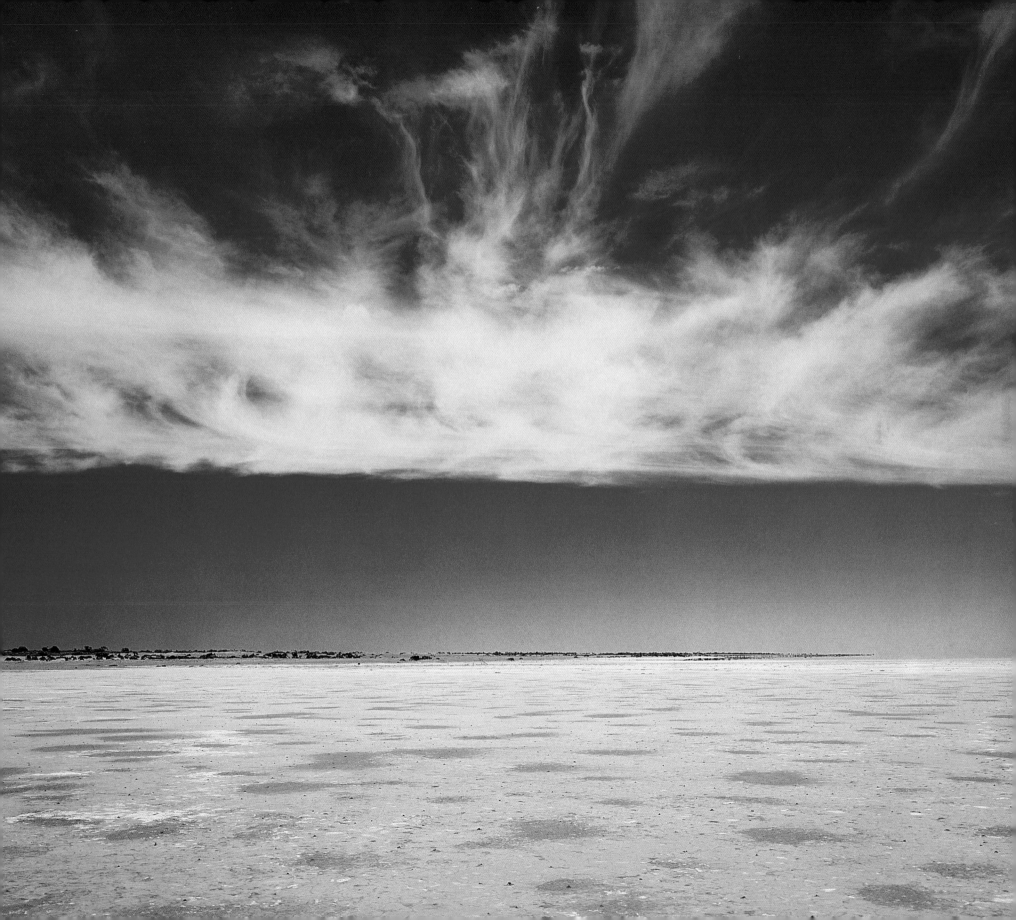

ROCKS AND MOUNTAINS

He says he likes freedom; it has something to do with coming from war-torn Europe and a rigid, boarding-school upbringing. Woldendorp points to the layout inside his house; 'See, there are so many doors that I can walk out of!'

He was never destined to sit in front of a desk or spend his life doing studio portraits. 'I like getting out of those of situations, I don't like being trapped by humanity. And I'm a bit afraid of authoritative power.' He thinks he's blessed – 'Even the mining companies give me absolute freedom to photograph what I like.'

For forty years, Woldendorp has enjoyed a rare periodic partnership with the same giant mining company; they give him licence to roam the outback mountain ranges of Australia, hiring him to document their activities.

He's often accompanied only by a geologist or two, experts who share Woldendorp's obsessive fascination with the landscape – but for entirely different reasons. In the craggy peaks and folded fault lines of Pilbara rock they see clues to the past that may lead them toward a future mineral discovery.

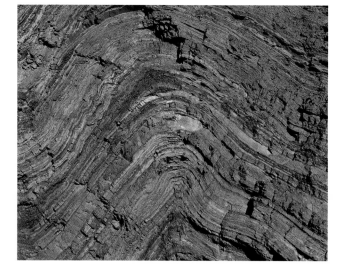

It's a little ironic that Woldendorp has forged such an amicable relationship with the miners. He's witnessed the way they have reconfigured whole mountains, erected 'giant meccano sets' on remote peninsulas and laid bare vast seams of precious metals. In many of Woldendorp's photographs are contained the history of human impact on the land.

But at the heart of the matter, he's not half as impressed by human endeavour in the outback as by the millennial changes that nature has wrought. Putting nature centre stage has become his credo.

It wasn't always the case. 'Even when I became fascinated by landscape, I always thought I had to put people or things in them. When I started in earnest to become a professional photographer, travelling through Australia in the late 1950s, I became aware it was under-photographed. There were not many photographic images that taught you much about the country – there were just the usual promotional touristy shots.' Explaining our landscapes to ourselves became his passion.

Some people have said Woldendorp's genius is to convey the monumental size of the land and its subtle underlying structures. Like the mysterious Bungle Bungle Range in the Kimberley region of Western Australia, etched out by millions of years of monsoonal rainstorms until what is left are beehive-shaped hills that extend to the horizon.

Dr Ian McLean, from The University of Western Australia, has compared Woldendorp's pictures with the works of Australian landscape painter Fred Williams. 'The irony of these photographs, also evident in Williams' paintings, is that we get a truer sense of the country in the more abstract images. They reveal more of the underlying structure of the landscapes, as well as the texture and feel of things.'

But even Woldendorp's most abstract images originate in nature. At the outset he needs real scenes laid out before him to inspire him. And then he will begin to adjust the camera to remove from view elements he feels are unnecessary. Like the line of the horizon.

'I only leave the horizon in if I want to show how the land goes on forever. I'm already at a thousand feet, and I've got visibility of fifty or sixty or eighty kilometres, and I think "What a great country, this is half the size of Holland."'

'But I often take the horizon out to focus the viewer on something, like the way spinifex grows or the repeating pattern of trees. I want the viewer to say, "Isn't this interesting?" But it is not easy to make a picture worth looking at … '

Fold upon fold of ironstone rocks in the walls of Hamersley Gorge, Karijini National Park, laid down over millennia by marine algae and bacteria. They are the source of Western Australia's bounty, over a hundred million tonnes of iron ore extracted each year for world consumption.

Opposite: A wall of conglomerate halfway up Hamersley Gorge. Trees have found root holds in pockets of finer sedimentary rock.

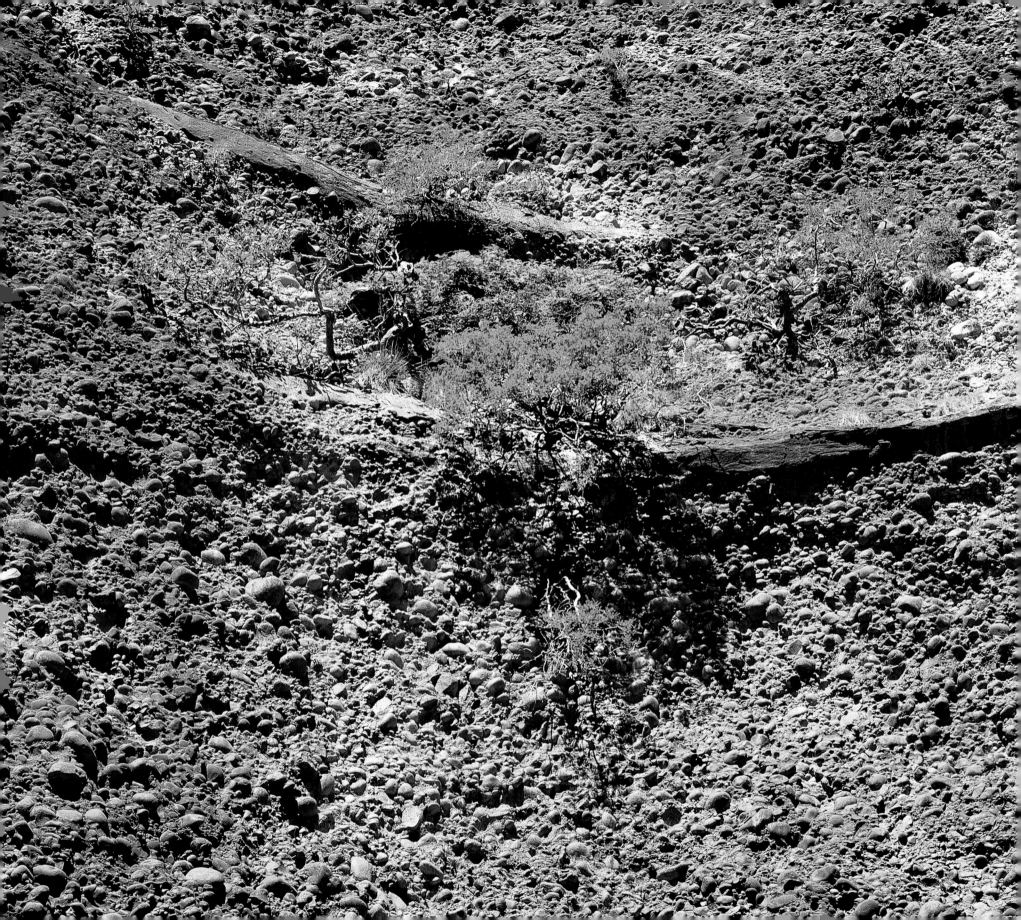

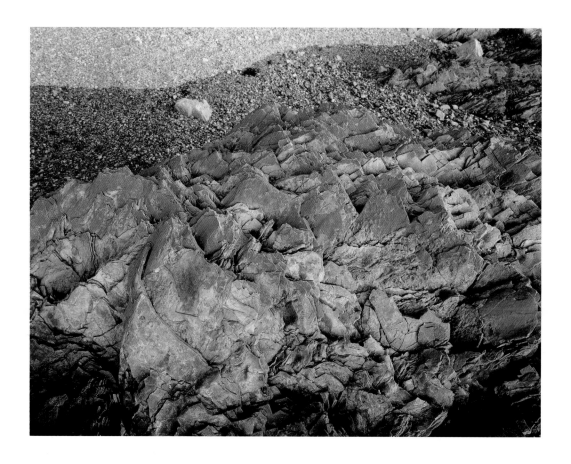

Red lichen covers shoreline rocks above the tidal zone near Burnie, Tasmania.

Opposite: An eruption of black rock, darkened by algae growth, in the monsoon
savanna country near Kununurra on the Western Australian — Northern Territiory border.

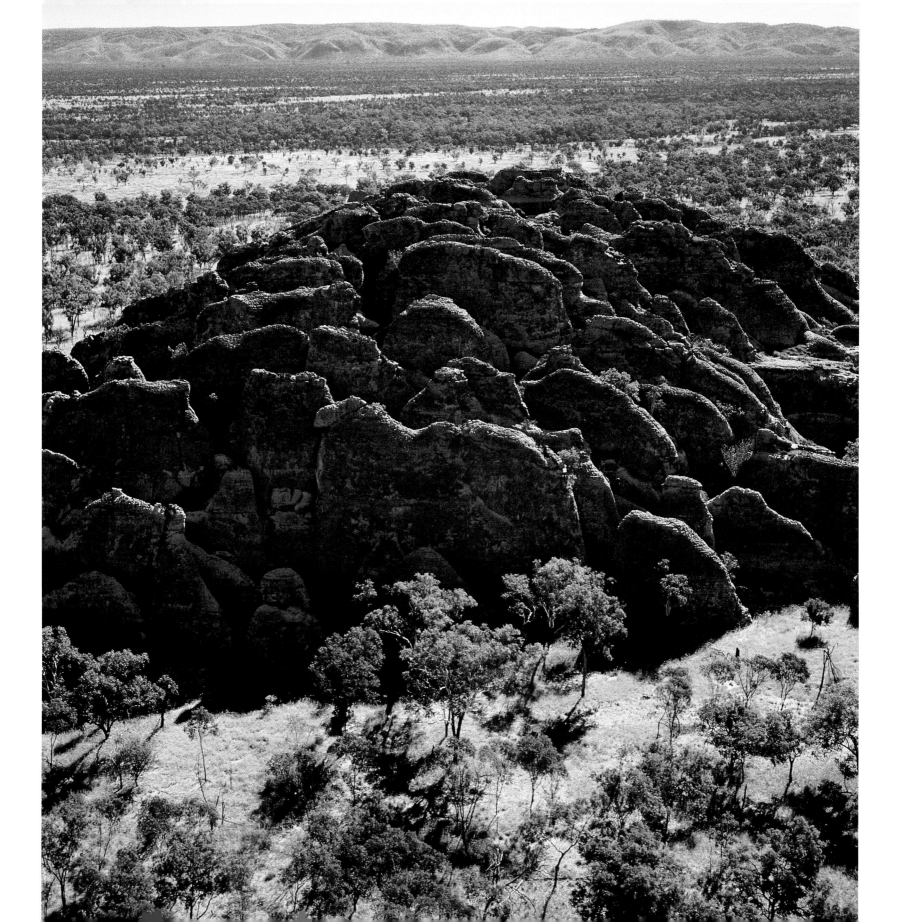

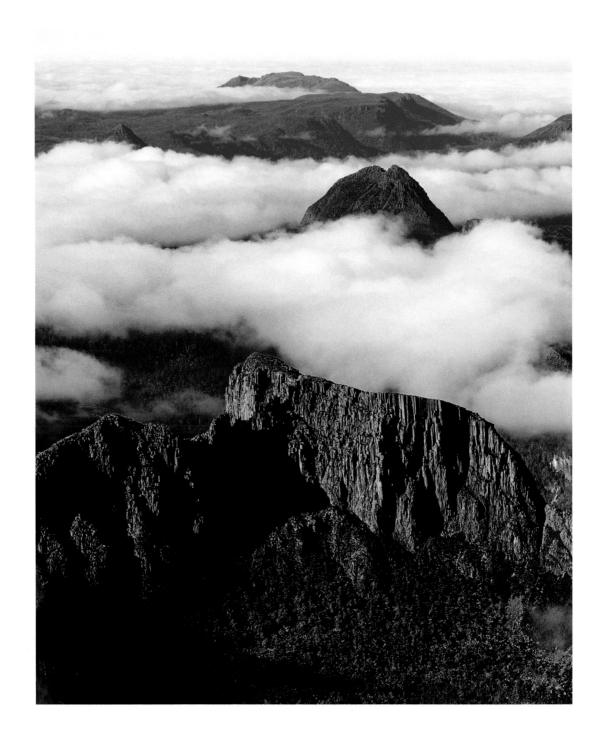

Giants among the clouds —Tasmania's famous Walls of Jerusalem are made of hard dolerite, a volcanic rock that once covered nearly half the island. Cradle Mountain-Lake St. Clair National Park.

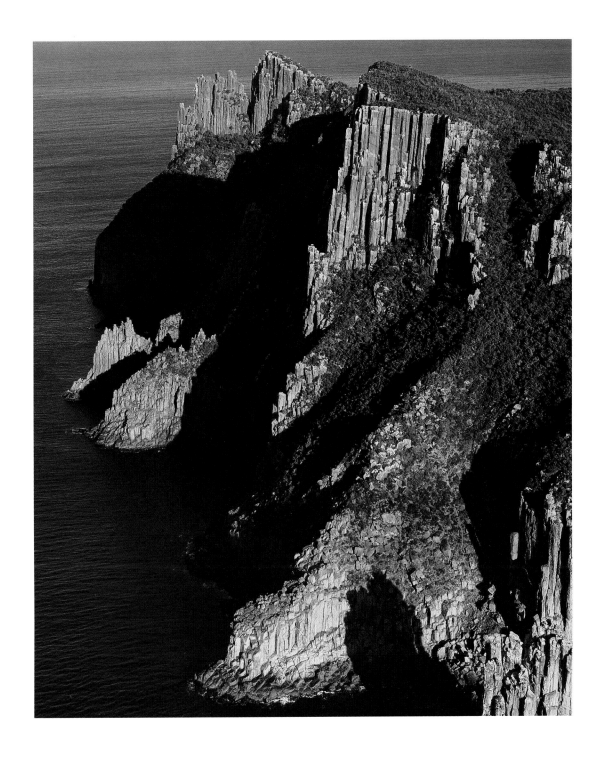

Cape Pillar's dramatic dolerite columns tower three hundred metres above the Southern Ocean, on the south-east Tasman Peninsula.

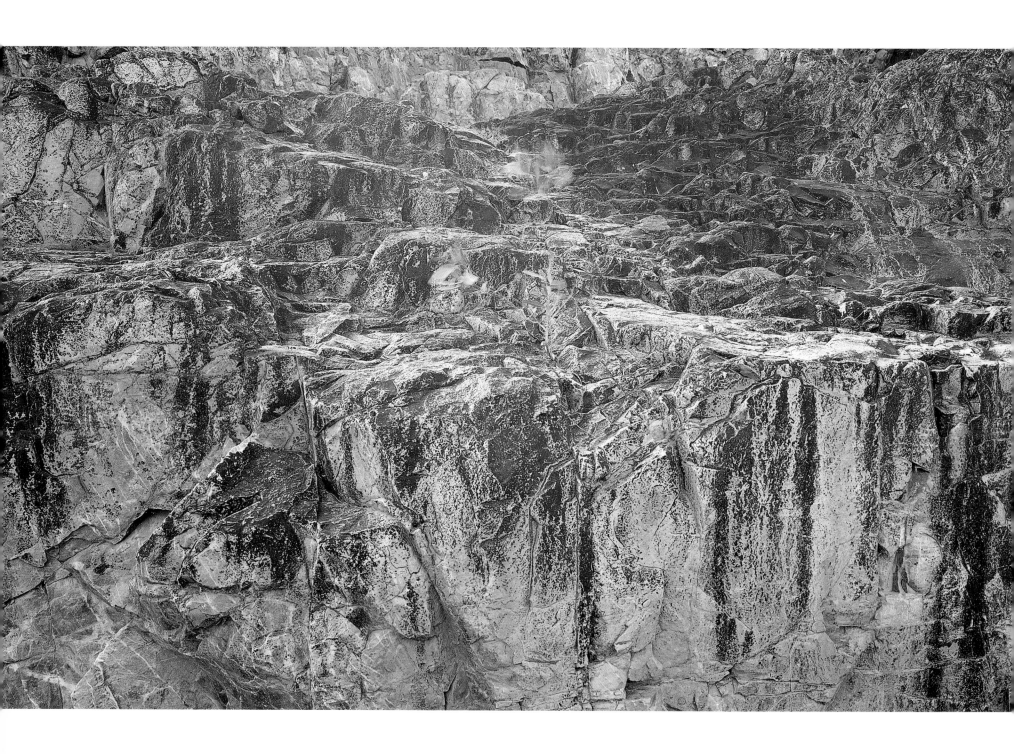

Mosses and algae add a blue-black tint to quartzite rocks in Central Australia.

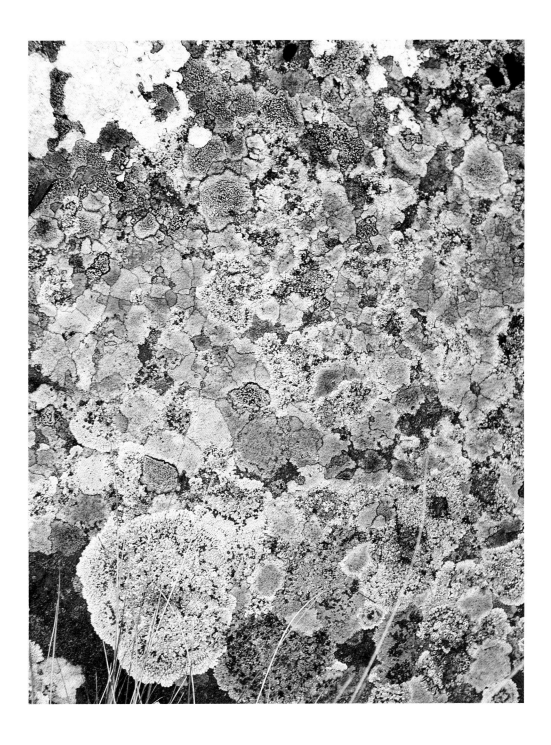

Symbiosis on a rock. Lichens grow on the damper side. Lichens are hybrid life forms and are in fact composed of two distinct plants, form-giving fungus and algae which provides nutrients to both plants.

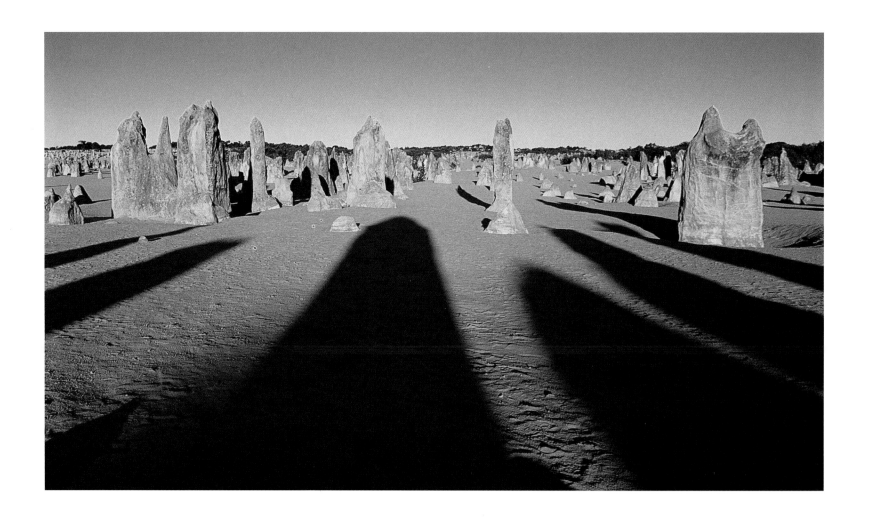

Eerie afternoon shadows cast by limestone pinnacles at Nambung National Park, Western Australia.

Opposite: A spiky-looking footprint in the sand — a cluster of pinnacles exposed by a dune blow-out.

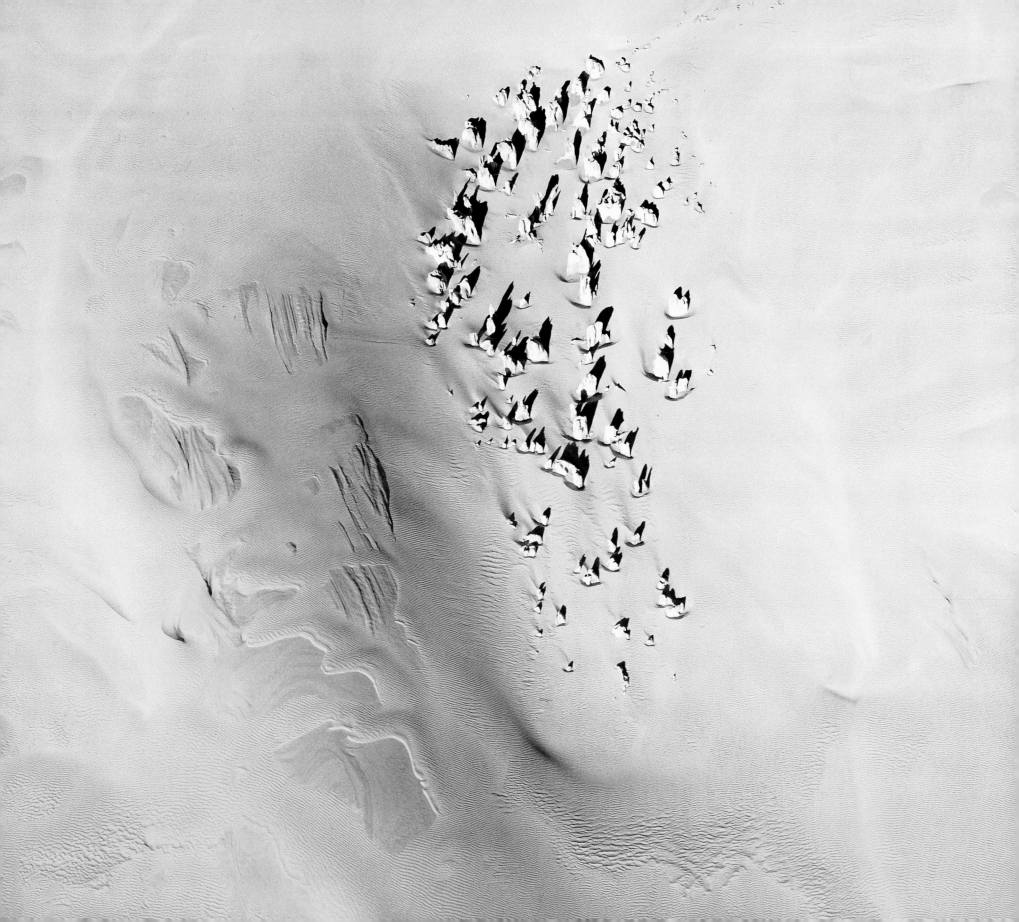

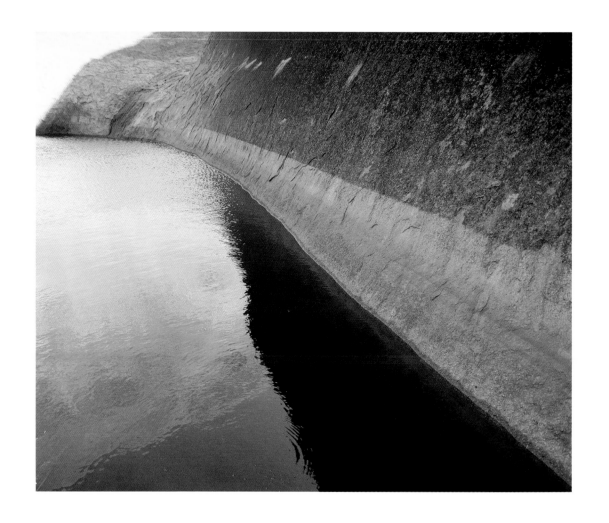

Reflections in a rock pool, Uluru, Northern Territory.

Opposite: Waterborne algae leave dramatic stripes on the face of Baladjie Rock, Western Australia.

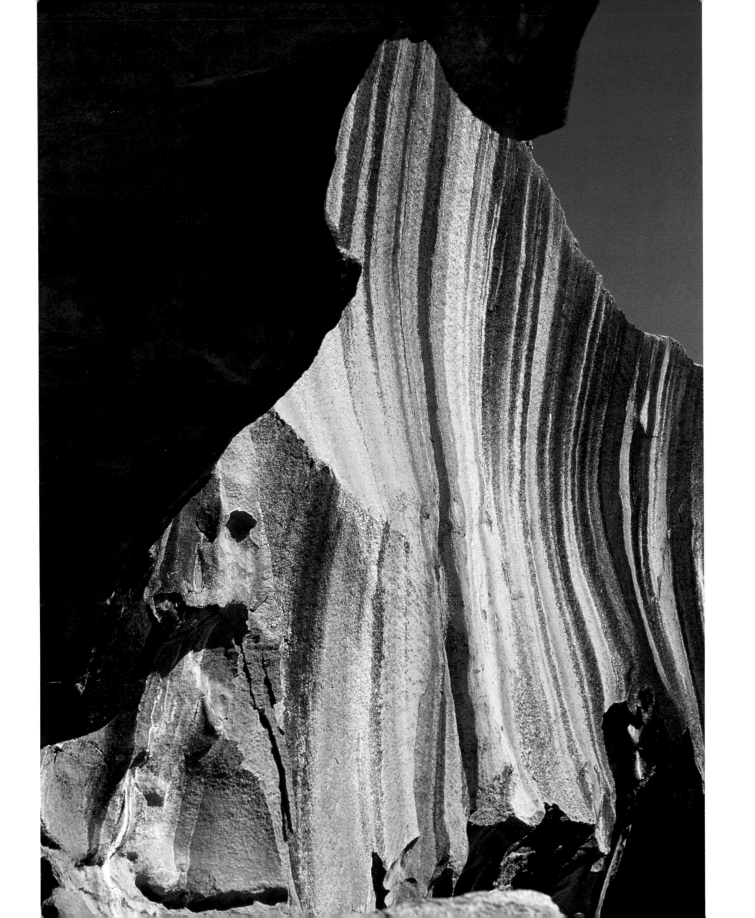

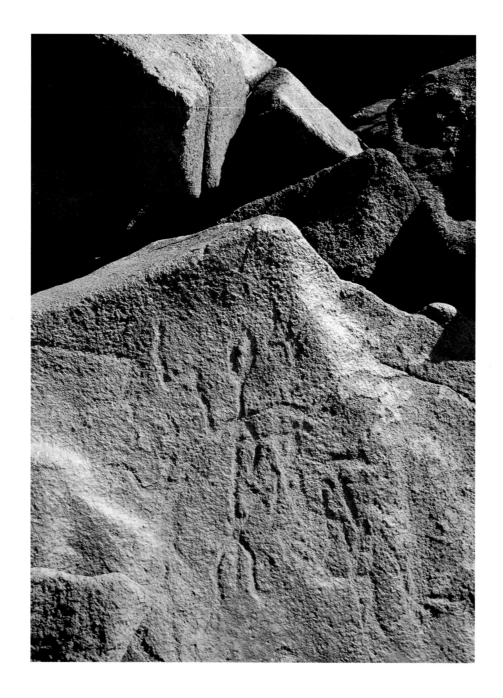

Man on rock — the outline of a boomerang-wielding man, etched into granite boulders on the Burrup Peninsula near Dampier, Western Australia.

Opposite: White ochre ghosts inhabit cavern walls at Keep River National Park, in the Kimberley region of Western Australia, where traditional Aboriginal owners have left a legacy of rock art.

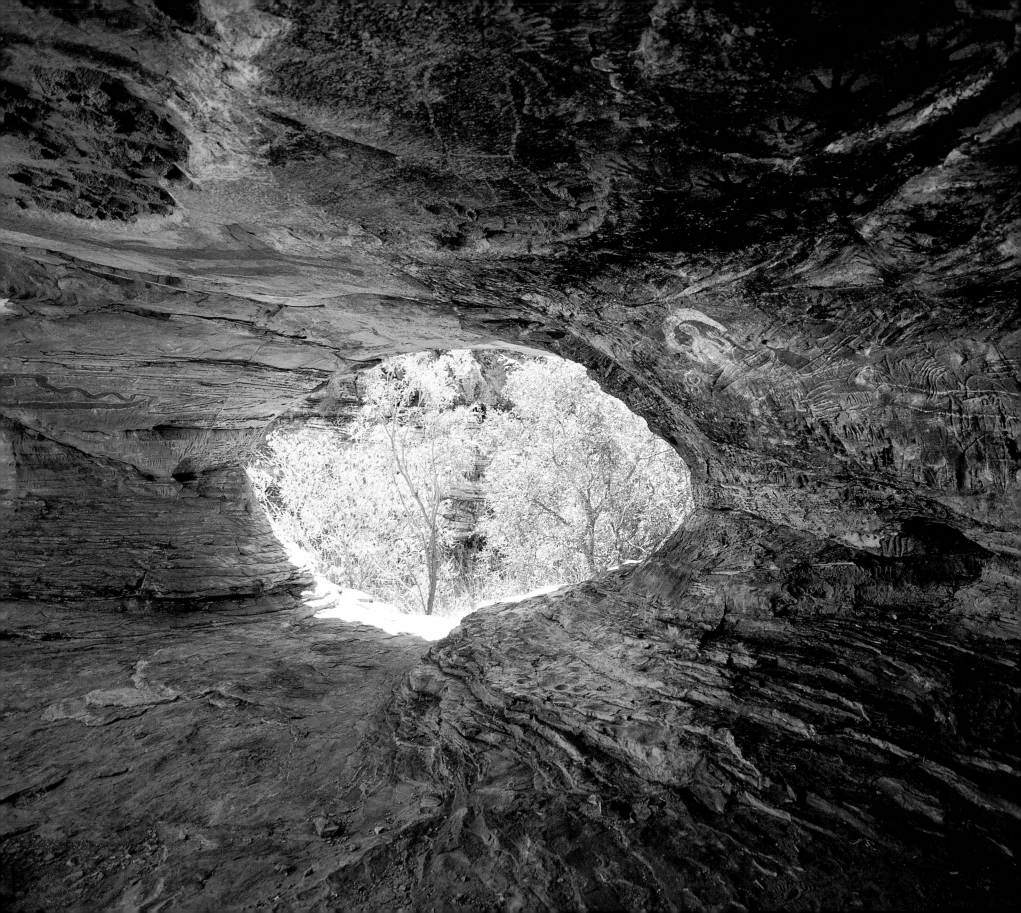

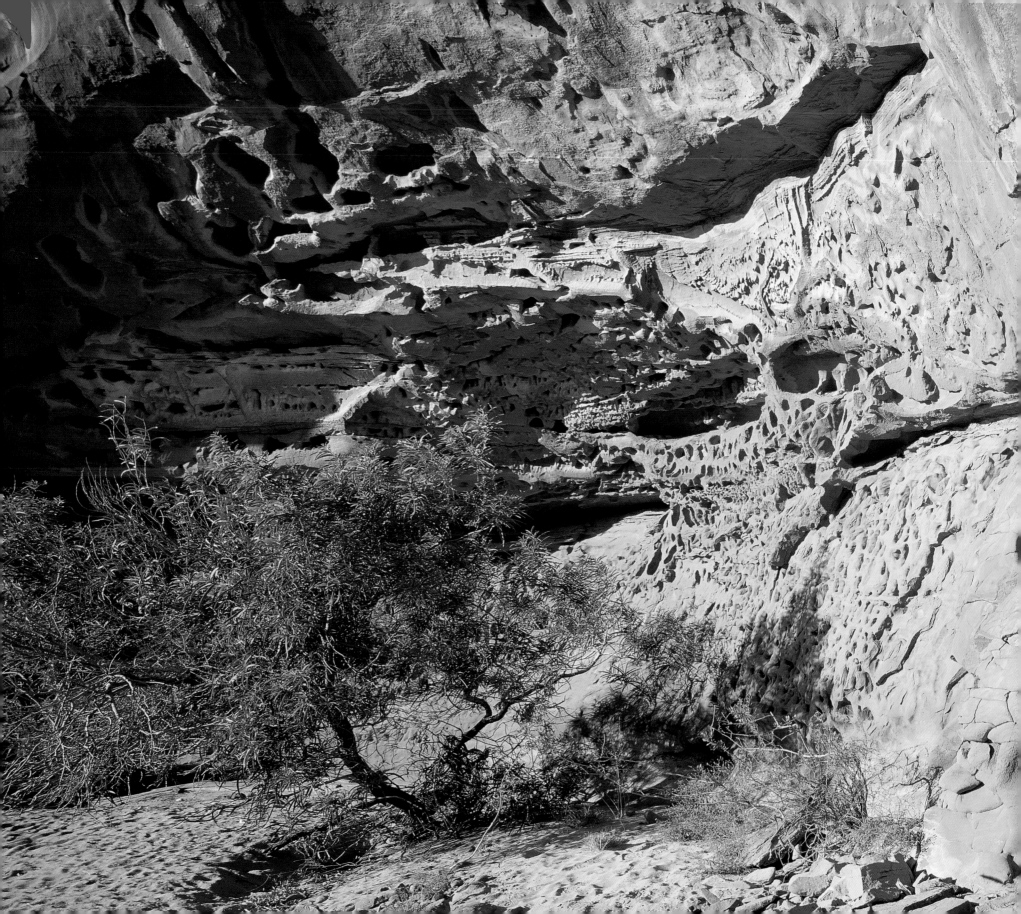

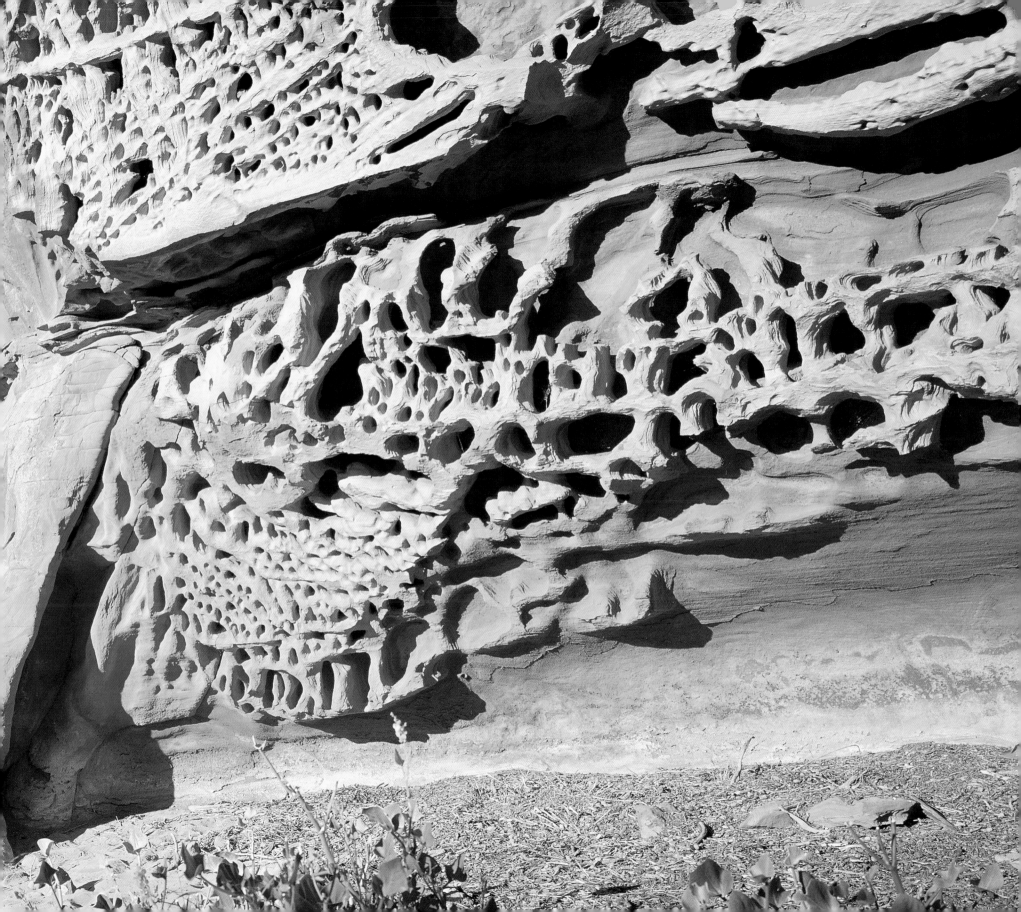

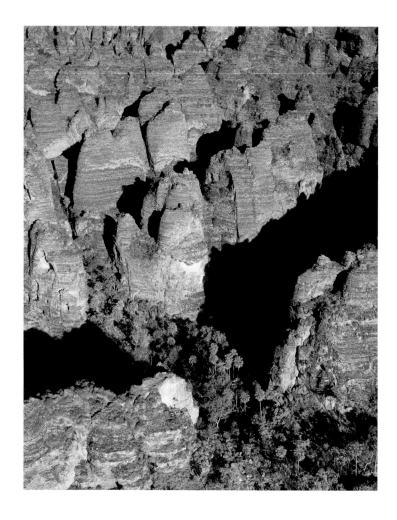

Striped domes in the Keep River National Park, Western Australia, where
uplifted sandstone has been bisected by chasms and canyons eroded by
running water. Animals shelter in its perennial cool shadows, including
the rare white-quilled rock pigeon.

Previous pages: Honeycomb weathering in the Kennedy Range,
Western Australia, resembles the skeleton of a giant animal. Salt in the
sandstone has become damp, expanded and loosened the surface, leaving
wind and water to gouge out all but the salt-free stone.

Opposite: The mysterious Bungle Bungle rock formations in Purnululu National Park,
Western Australia, have been etched out by millions of years of monsoonal rainstorms.

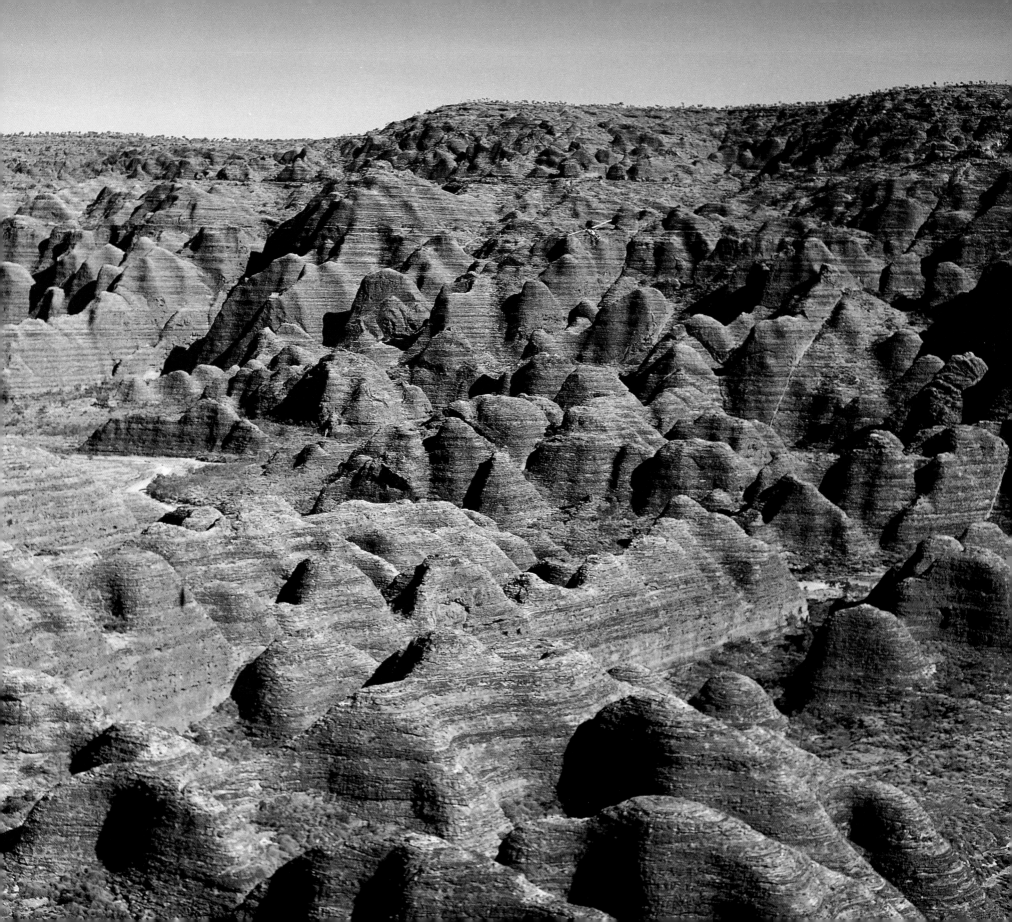

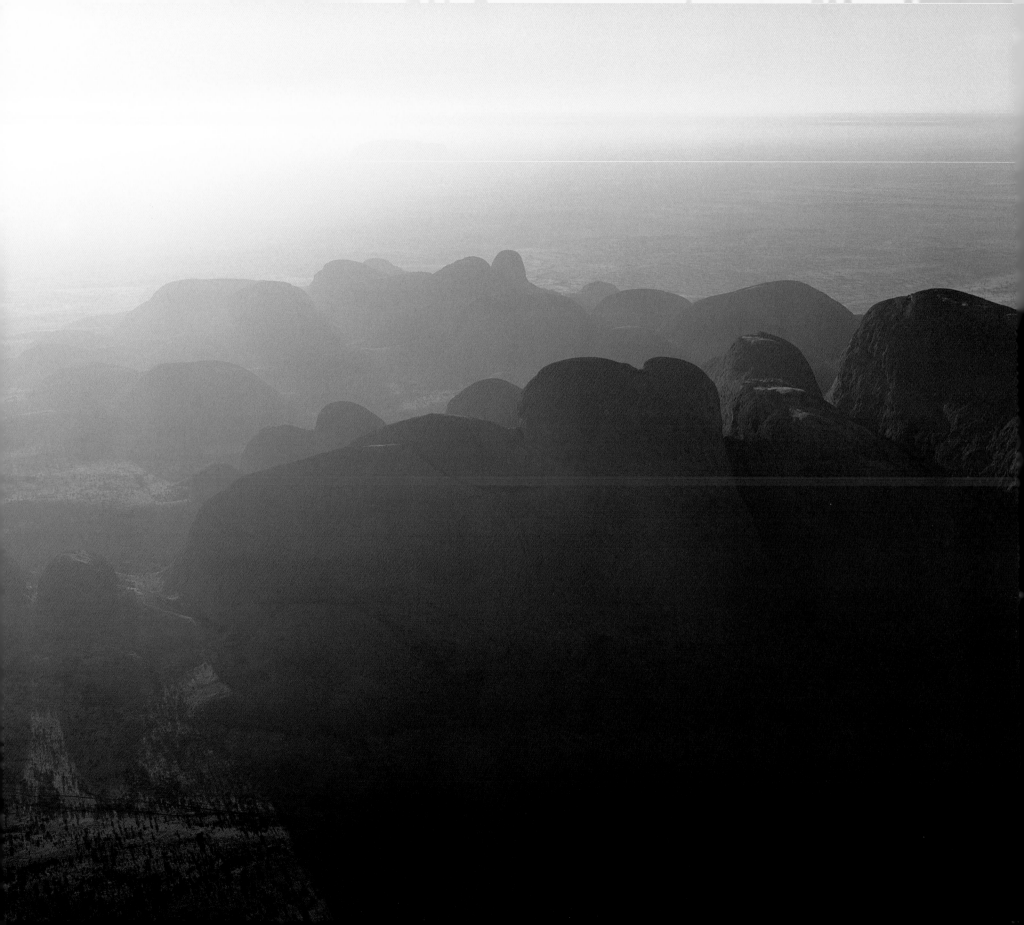

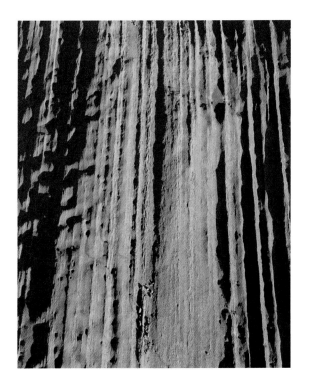

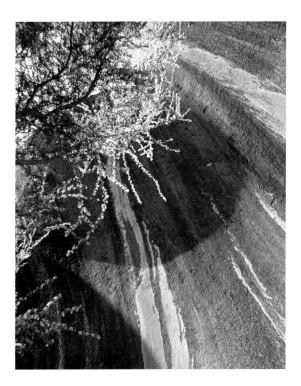

Left: Like a rusty corrugated iron roof, the summit of Uluru, Northern Territory, reveals the upended edges of many layers of soft and harder layered sandstone.

Right: Spring at Beringbooding Rock, Western Australian wheatbelt.

Opposite: A distant Uluru suffused by morning light, and in silhouette 'the land of many heads' or Katatjuta, the thirty-five domes of the Olgas.

AUSTRALIAN FLORA

From the air the patches of spinifex resemble patterns in a Central Desert Aboriginal painting. The plant grows outward from the parent plant, creating a jelly bean pattern that is repeated across many metres of ground.

Tough and drought resistant, each bush is a prickly sanctuary for small mammals and reptiles in a treeless envioronment, Alan Fox has explained. Woldendorp admires the scientific knowledge of people like Fox, but admits he personally doesn't have to know every detail to appreciate it.

'I don't look at the landscape simply to gain knowledge. I'm terribly small in it, and I don't want to know what kind of trees there are … I'm just interested in the fact that it is there, that it came from four hundred million years ago and this is the end result that I can marvel over.'

He looks at natural phenomena with a freshness of vision few of us possess. Maybe it's because this foreign-born Australian has not grown up with our creatures and plants. But then, nor have many native-born Australians who hang around the edges of the Australian continent, in insulated dormitory suburbs with exotic gardens.

Woldendorp is a little perplexed by Australians' unwillingness to venture into the interior. And people's affinity with their own geography, their home turf, is still shallow in Australia. 'I think country towns are there for economic reasons, not for traditional reasons like in Europe. You live there, you work there, you're a farmer or you service the inland farming community. But if you had a preference you'd live in the bigger cities and as close to the waterfront as possible.' He thinks that's why it is so noticeable that Aboriginal

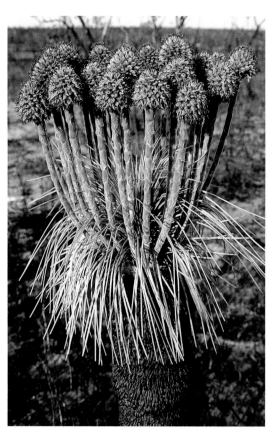

inhabitants of an area have a different way of looking at land, why they possess a different knowledge about it.

He's intrigued by these two kinds of knowledge, the scientific knowledge of a geologist or a botanist and that of Aboriginal people. Both appeal to him, 'And I have the skill of neither of them!' he laments half-heartedly. 'But I think I'm more drawn to Aboriginal knowledge – they look at things that are important to their own survival, and that code is handed down.

'I'm not of course dependent on that knowledge for survival, but I need to know the basics when I'm going bush. I want to know what the tree can do for me, rather than the name of the tree.'

In the photographer's mind's eye, his next book has already emerged. He wants to juxtapose the brilliant insights of Aboriginal painters with his own photographic images of landscape. He thinks it could be a kind of reconciliatory gesture, a coming together of points of view. 'We non-indigenous people don't have the same sympathy or pay the same homage to the land.

'In painting, you start with a blank canvas and work until you're satisfied you've got what you want. With photography, it's the other way around – you usually start with too much. Unlike painting, you start with the optical reality within the framework of the camera you use.

'I say to myself, "Condense the subject matter, rather than expand it". I've got to get rid of unnecessary details that are in there. So I use one or two characteristic components of the picture and I strengthen the composition.' Like a breaking wave, or a shaft of golden light, or the leaf-like veins of a river delta.

Flower spikes on the grass tree *Kingia*, after a bushfire.

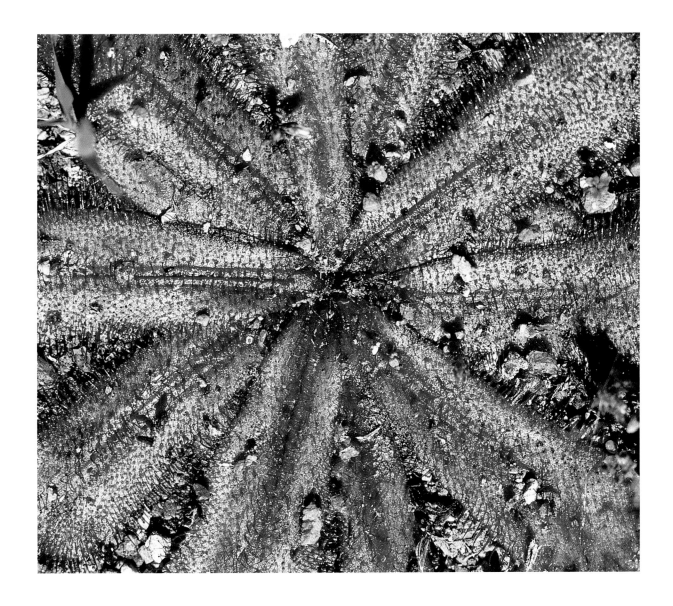

An insect-eating sundew plant offers up its sticky leaves to unsuspecting prey, whose fate is to be sucked dry of the nitrogenous elements lacking in the plant's own habitat.

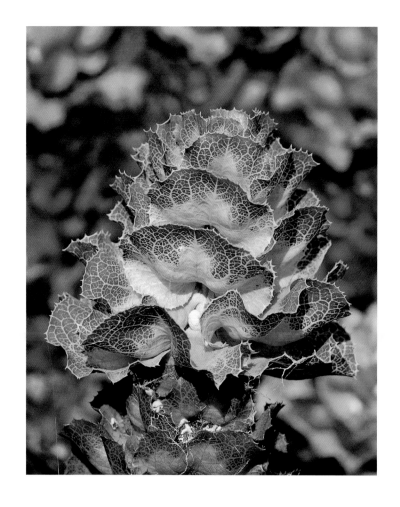

The showy magnificence of *Hakea victoriae*.

Opposite: Tree fern gully in a rainforest near Yarram, Victoria.

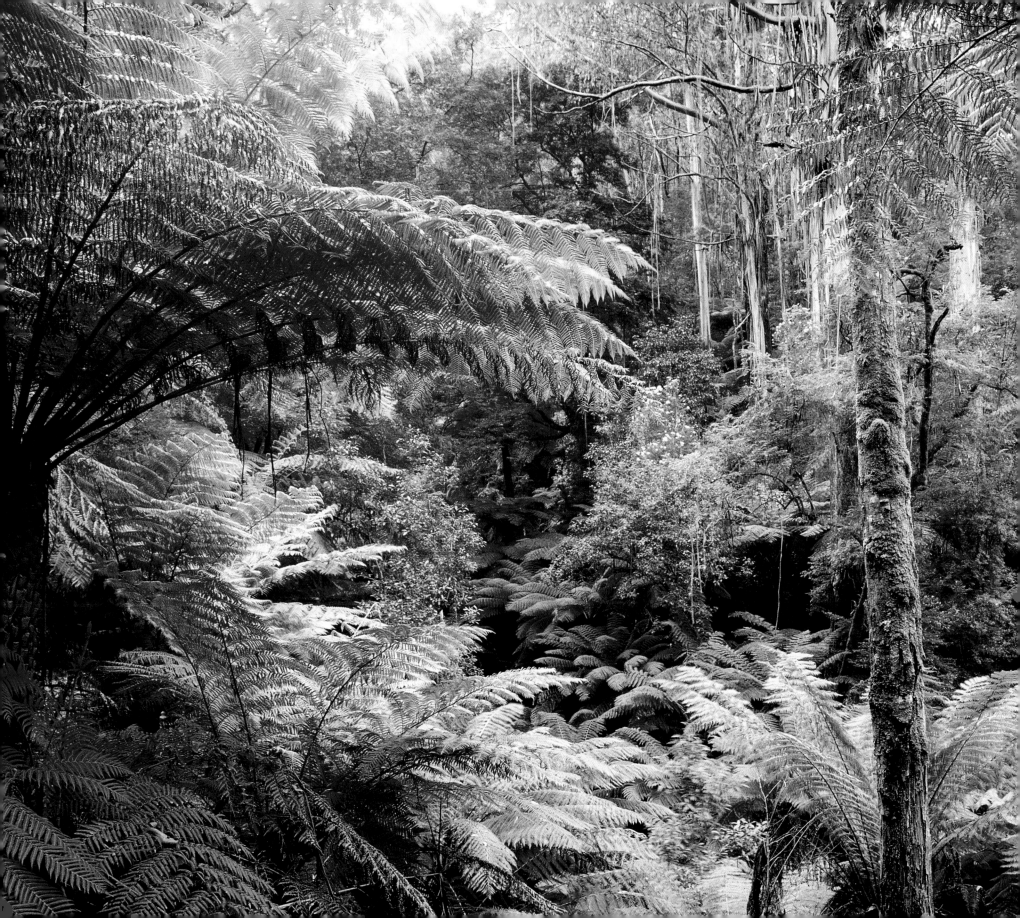

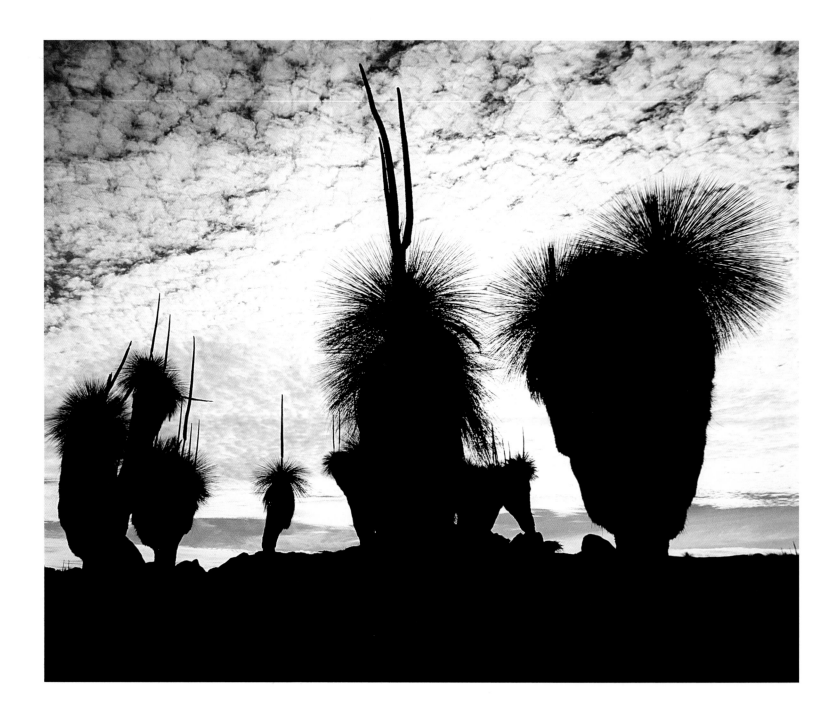

Grass trees with flowering spikes stand out like tufted sentinels from Cape Byron, New South Wales, to Kalbarri, Western Australia, from coast to desert.

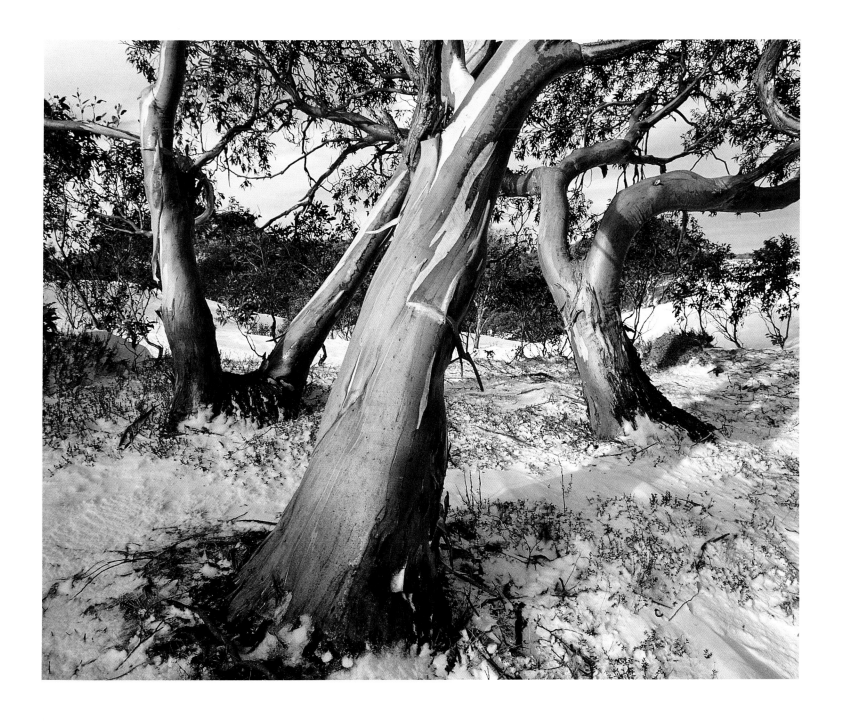

Snow gums shed their bark, but not their leaves, in winter to reveal pink new layers.
These twisty-limbed giants dot the high plains country of Victoria.

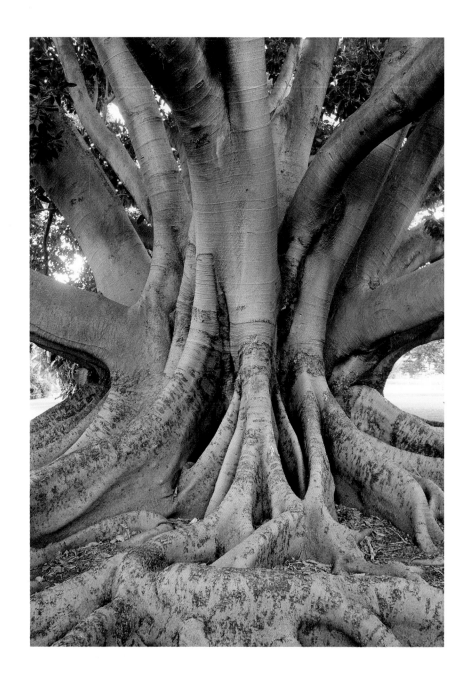

Two structural feats of nature — a Moreton Bay fig's massive buttress of surface roots, and the filigreed tangle of a deciduous tree.

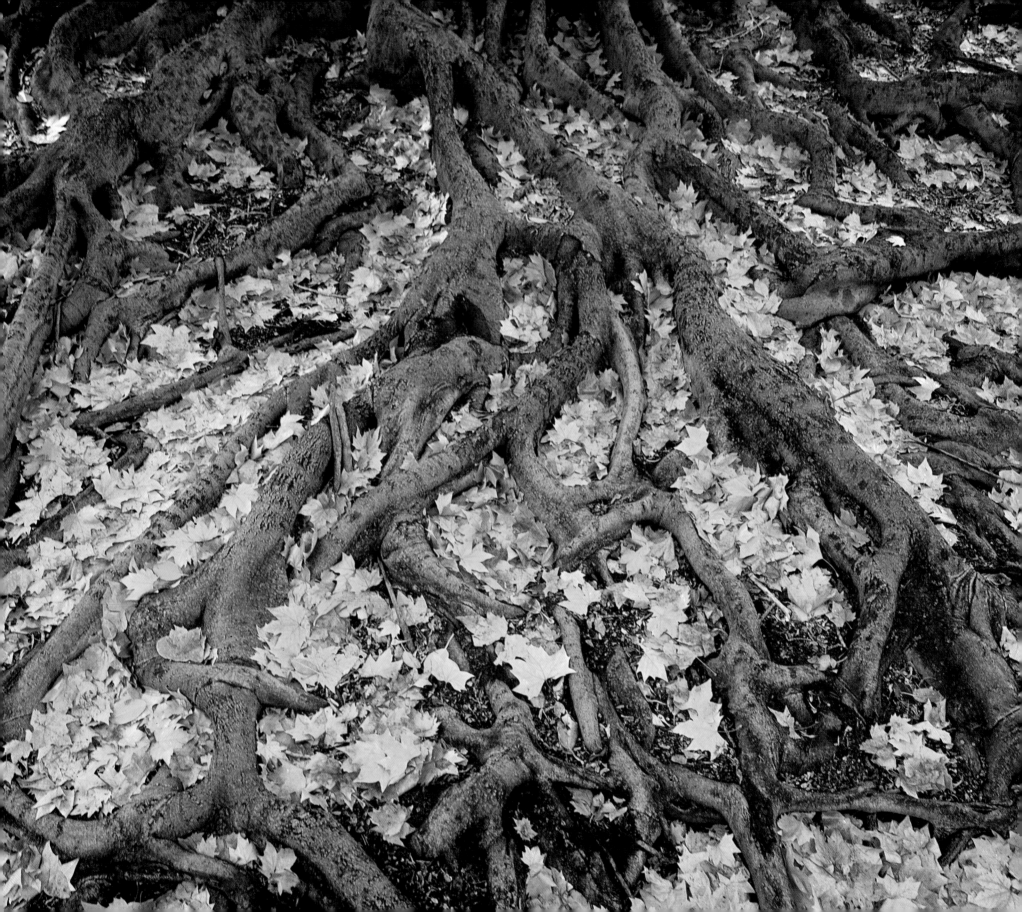

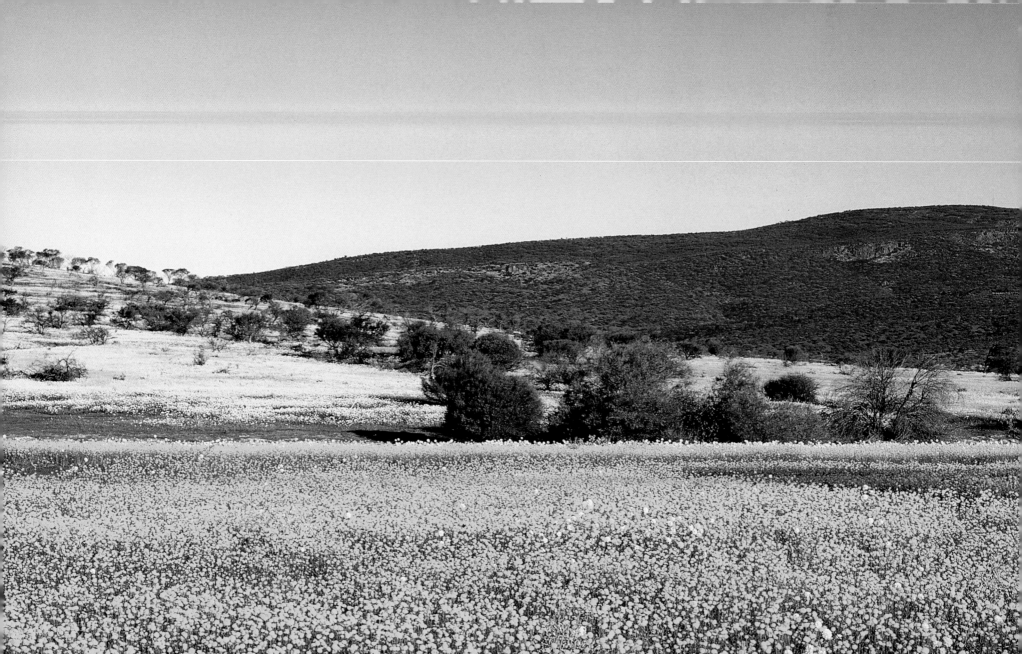

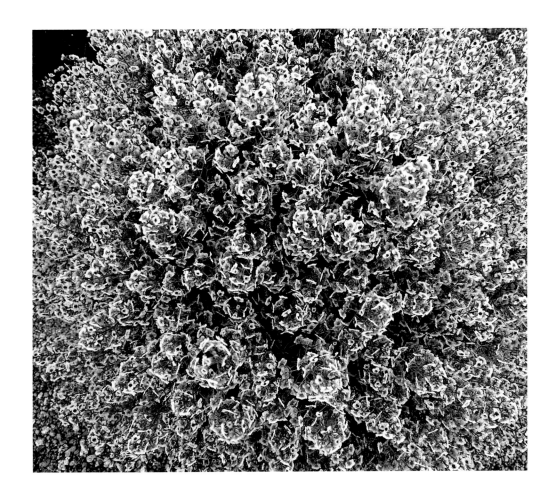

Just add water – and the lace-like flowers of *Cyanoslegia augustifolia* burst forth.

Opposite: After rain, deep drifts of gold and white everlastings bloom at Landor Station,
in the mid-west of Western Australia.

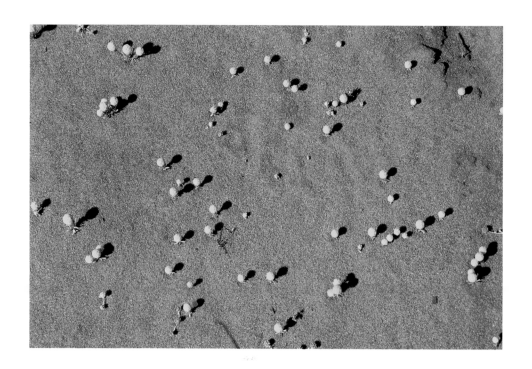

After a deluge, tiny daisy flowers pop their heads from the red sand, in
a frantic bid to pollinate before drought overtakes them again.

Opposite: More delicately hued than any English garden, this riotous tangle
of wildflowers appears after rain across the mid-west interior of Western Australia.

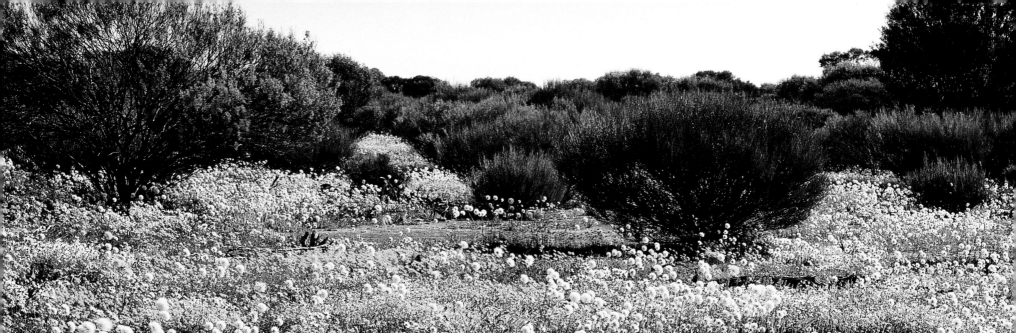

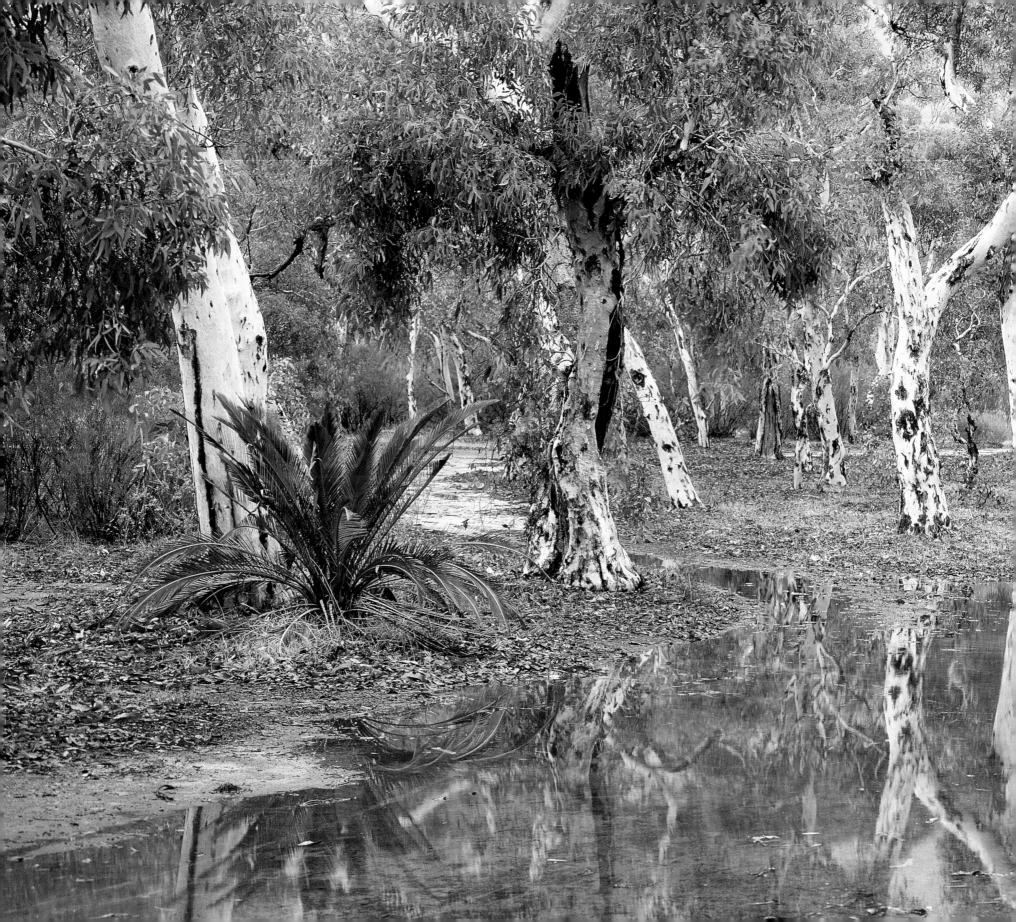

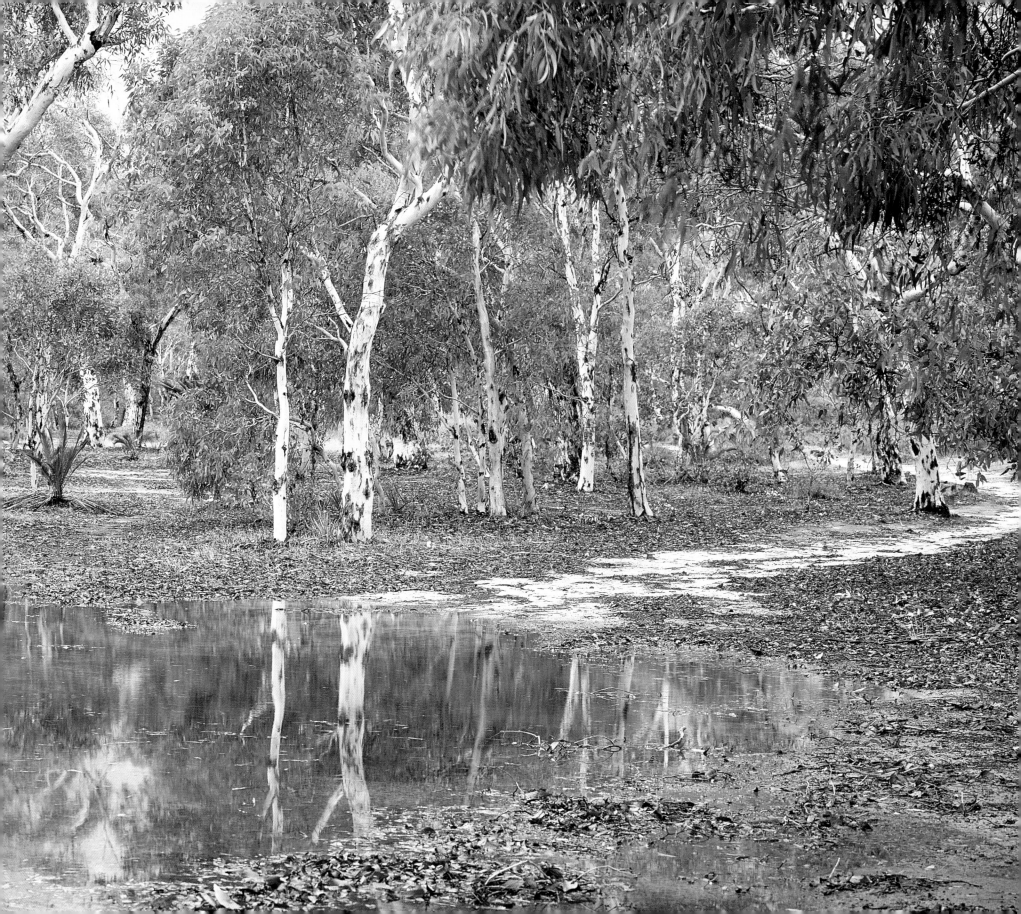

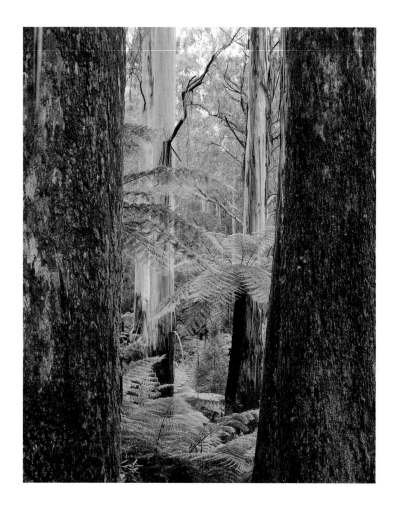
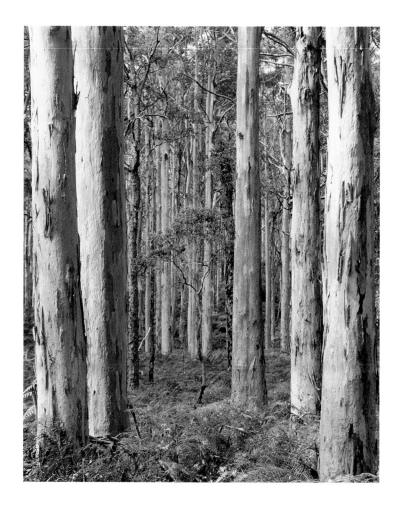

Left: Survivors from decades of tree felling, these grey-sided giants grow in
a protected swamp gum forest in Victoria's Bulga National Park.

Right: In the West, these karri trees are the result of regrowth after native forests were logged half a century ago.

Previous pages: Quiet grandeur in the wandoo forests north of Perth, Western Australia. The white-trunked
eucalypts standing in a wet season lagoon.

Opposite: A bird's-eye view of Australia's eucalyptus forest — tree canopy in karri and tingle stands, glimpsed
from a tree walk near Walpole, Western Australia.

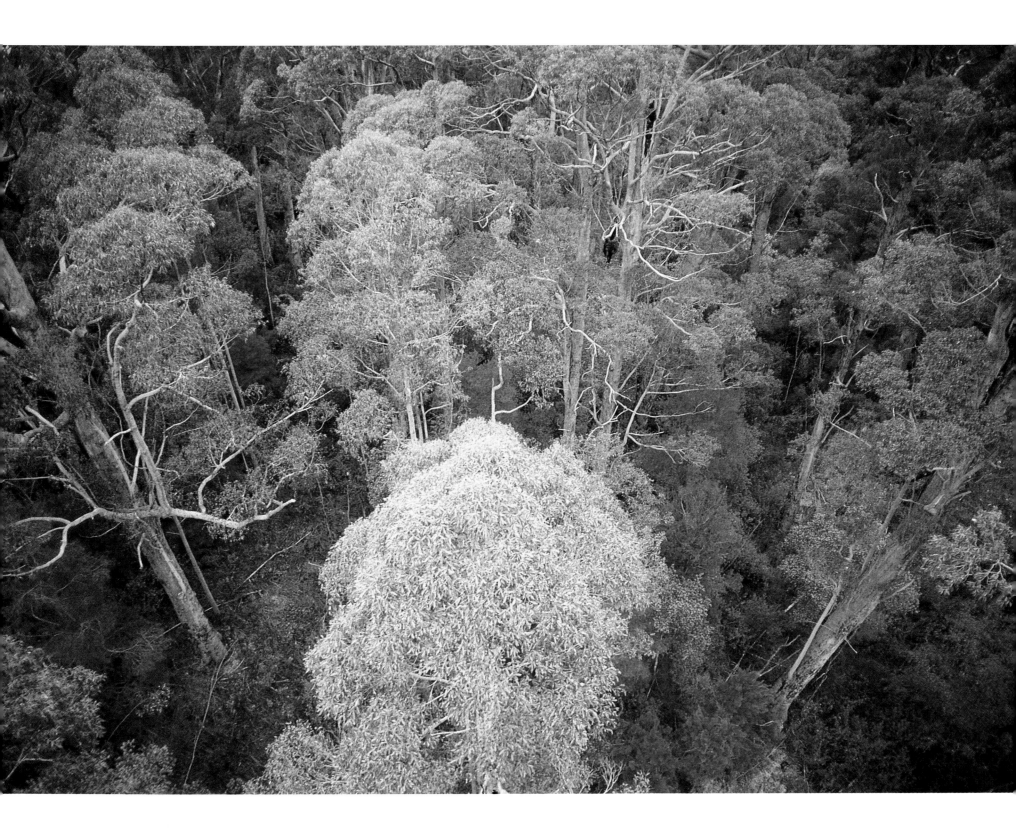

RIVERS AND BILLABONGS

Woldendorp has an eagle eye, or perhaps a parrot's — he can home in instinctively on the blip on the horizon, a startled flock of birds, a tiny flower or prismed light as it seeps through low cloud. A lone marsupial standing erect on a boulder-strewn embankment.

He's alerted to unusual features in the landscape through differences in colour, a heightened sensibility that may derive from his early training as a commercial artist; 'It helped tremendously with balance, colour and composition.'

Every photographer is drawn to bodies of water, from tranquil billabongs to flash floods that trigger the growth of wildflowers. Woldendorp is no exception but he also captures moisture in midair, in thunderclouds bringing the promise of rain in the Northern Territory's Missionary Range near the Simpson Desert. 'Rarely does rain fall there, but there's a hint of a possibility, shadows here and shadows there.'

To what extent does he wait for the right picture to present itself? 'Sometimes I sit there for an hour to get it, if I want a perfect lace pattern from a breaking wave. I also walk along the beach, but sometimes the surface is not quite the same elsewhere. Cable Beach in Broome is perfect for that.'

There's also an element of luck. One memorable evening at Bermagui, on the New South Wales coast, Woldendorp captured a series of blue-black images as spare as a Japanese ink painting.

'There was a storm and it created a strange light, turning the night a saturated blue, and there was a wildness of waves over the black rocks. I took a twenty-second exposure and the whiteness of the waves became the mist in the picture.' Long exposures are exciting, he says, 'You're not in control, and you get unexpected results.' But he's never recaptured the light on that night again.

Getting pictures at ground level, as opposed to in the air, has its logistical problems. 'When you travel through rural Western Australia,

for example, basically you drive between two rows of barbed wire. You can't get off the road and if there is an interesting hill with a view or remnants of forest on top of a hill, you can't get to it because it's private property.

'It's one of the unfortunate things about Australia — they didn't design roads around the beauty spots and incorporate them, or provide parking space or stopovers where people can wander about the bush. In the station country up north the fences disappear and the country is more open — you have at least the illusion of freedom.'

Woldendorp has a fanciful notion that artists could one day be hired to design man's intrusions, from roads to car parks, along more aesthetic lines. But he's not holding his breath.

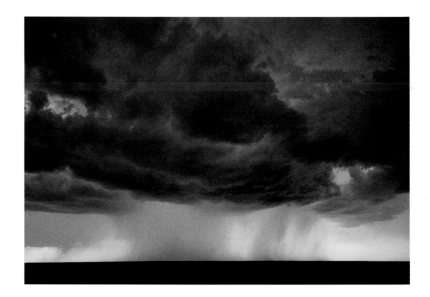

At sunset, a downpour of rain in the desert.

Opposite: Dry season seepage pours down to form a gentle stream in Hamersley Gorge,
Western Australia. where raging torrents flow in the wetter months.

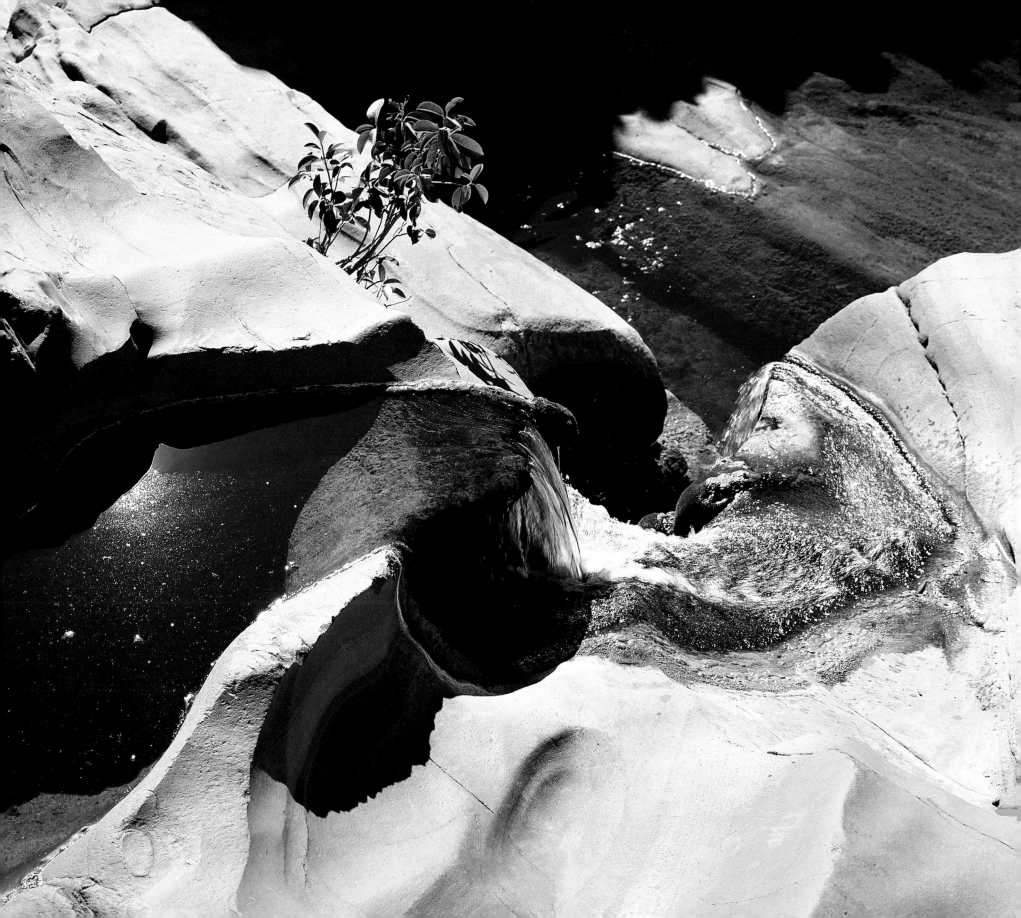

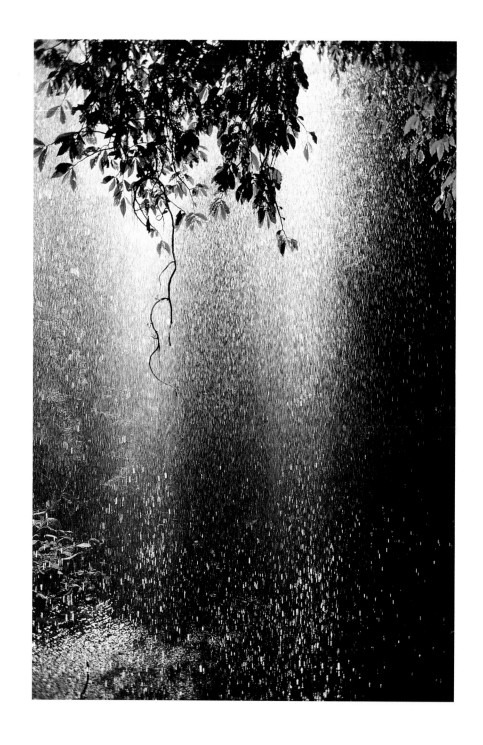

Crystal Shower Falls in Dorrigo National Park, New South Wales, which flows
into the headwaters of the Billuger River.

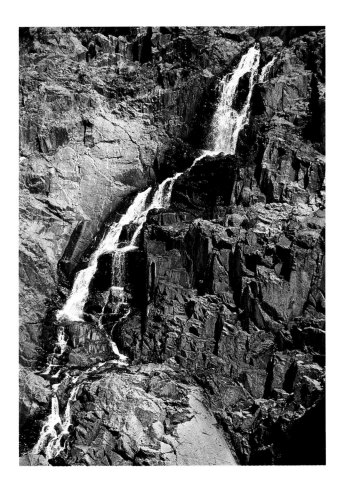 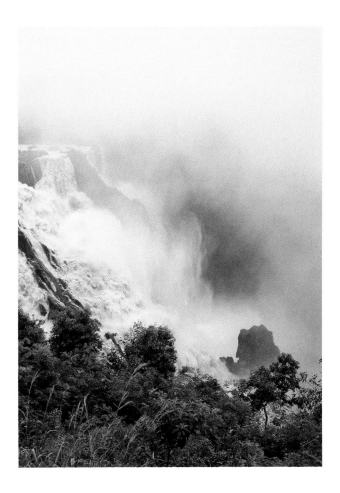

From trickle to torrent — the Barron River, west of Cairns, Queensland, in the dry season (left) and after a February cyclone (right).

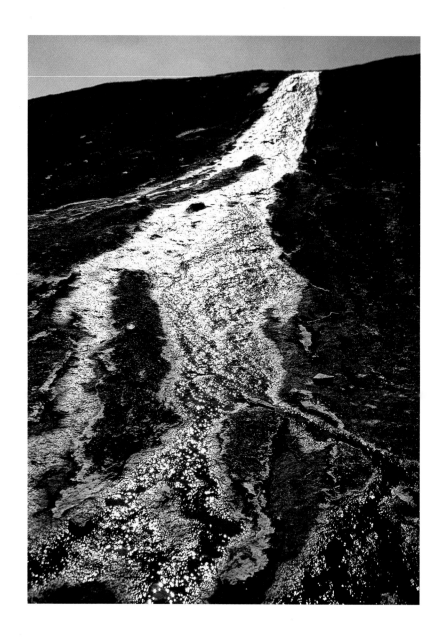

Above and Opposite: Water seeps in shiny ribbons across the surface of
rocks — seemingly impervious, even these rocks will succumb over time to
water's eroding powers. Uluru, Northern Territory.

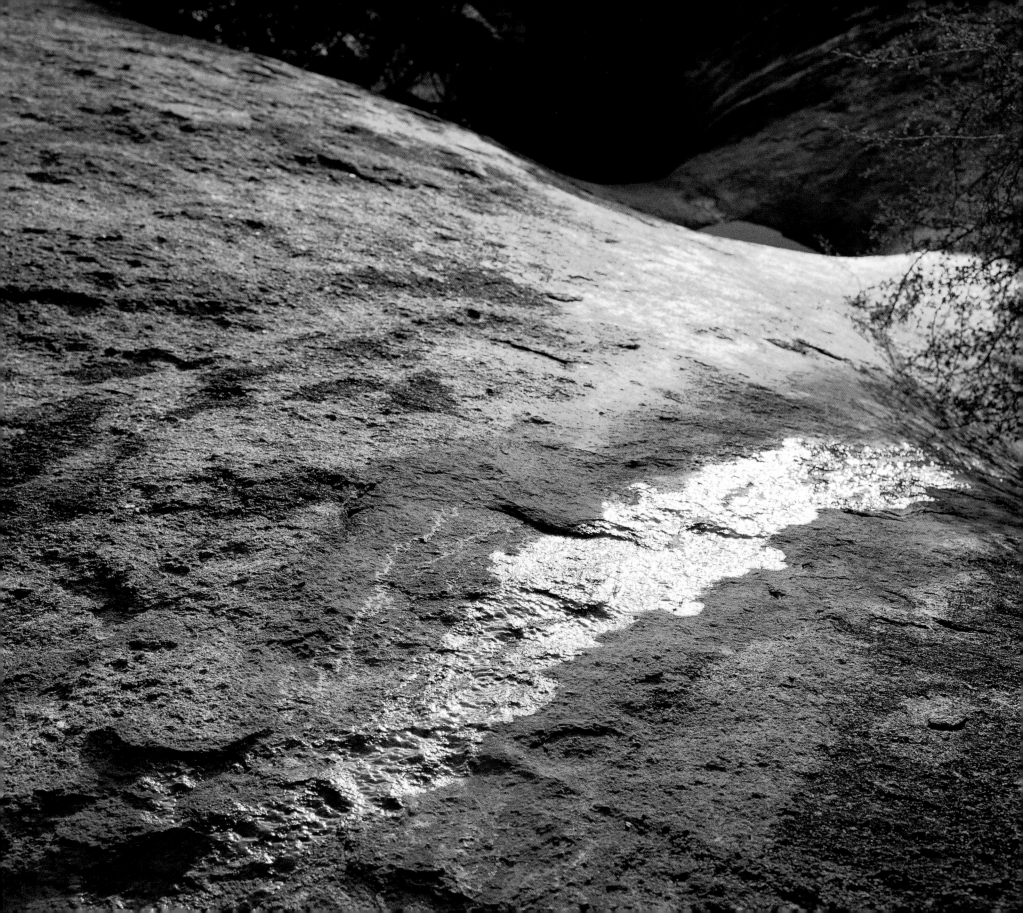

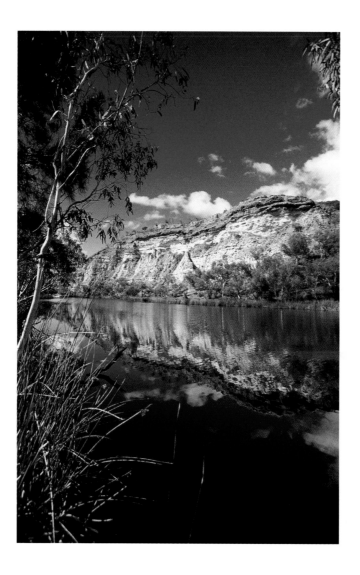

Above and Opposite: Isolated pools of tranquillity, these
inland waterholes have succoured explorers, Aborigines and early
settlers over many decades. They still offer refuge to itinerant
travellers and wildlife in summer.

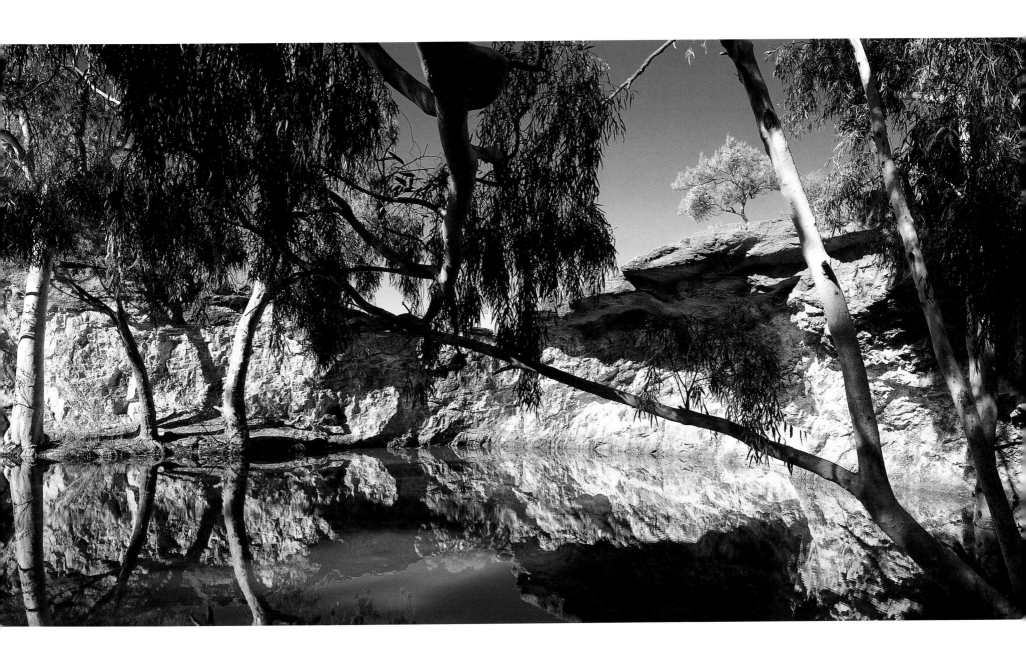

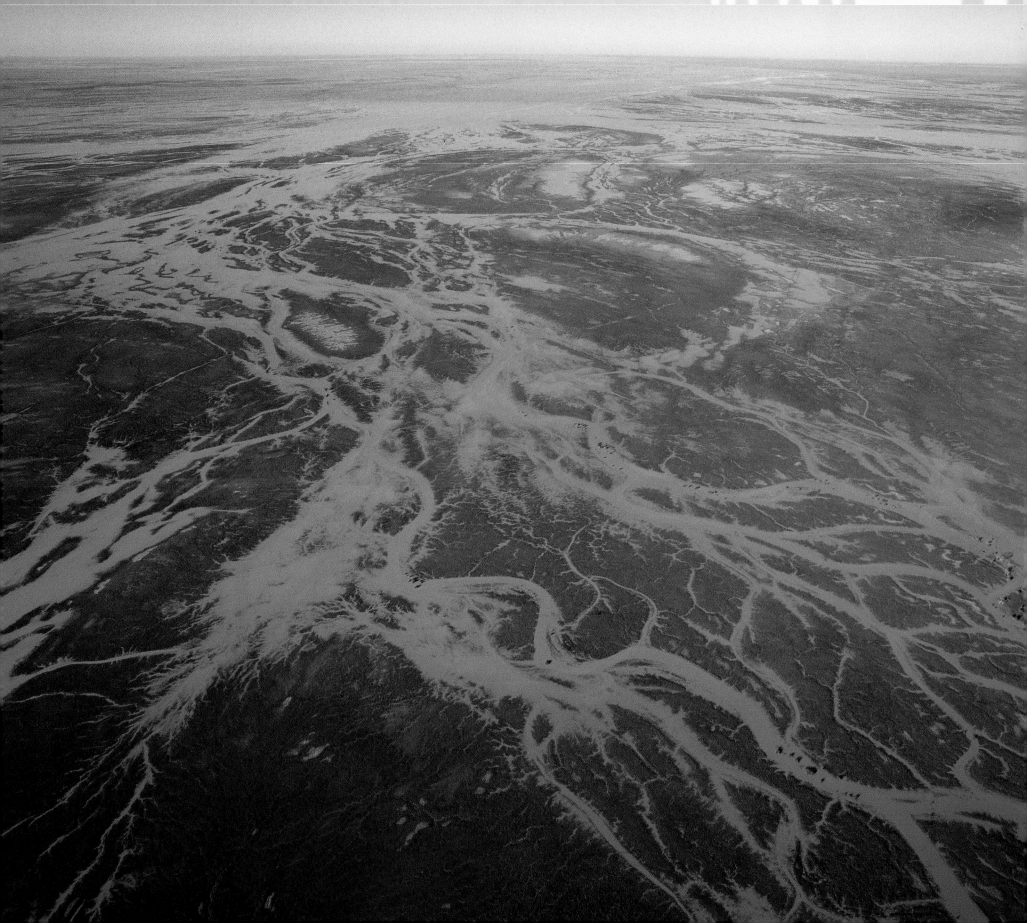

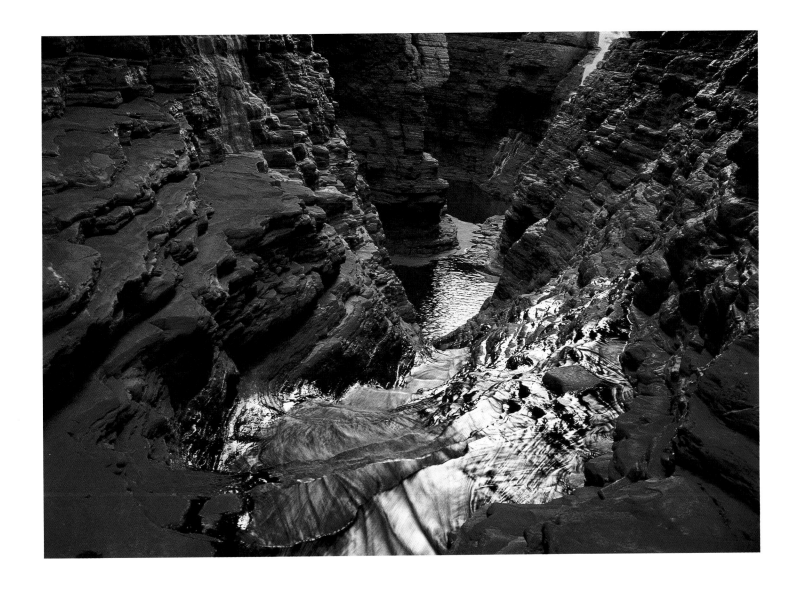

Hancock Gorge, in the Pilbara, Western Australia, its opal-like mica transformed by water splashing over rocks.

Opposite: Rivers of the Red Centre converge at Goyder Lagoon, before flowing on into Lake Eyre, South Australia.

WILDLIFE

He's rung to tell me he's heading off on another extended excursion, hitching a lift in the aircraft of a trusted pilot friend. 'We're going to be flying around the Nullarbor, and then Victoria and finish up in Queensland, before coming back through the middle. I don't know what for yet, but I just do it because I know something will come out of it.'

In a technological age in which we're all watching too much TV, Woldendorp wants to produce images that will refresh our vision. But does he sometimes wonder if he's running out of ways to present the world? Is there some effect, some picture he's still aspiring to? 'I think I'll be incapacitated long before I get there!'

'Maybe I'd like to film Antarctica,' he adds later. 'I like the sculptural quality of that landscape, and I grew up with snow and ice for twenty years.'

He says he loves interacting with other creative people, like painters or writers or poets. 'We all are willing to keep exploring our environment, we don't say so easily, "This is finite, I'm not going to take anything more in".'

'Certainly in photography, people love looking endlessly at people, and it doesn't matter whether it's people at war, fighting and dying, or relaxing or modelling fashion. But now, there's more focus worldwide on our survival, and how the landscape will survive. I feel drawn to that more, even though I have a whole portfolio of photo-journalistic work. I'm more and more attuned to what is out there as I get older.'

Woldendorp is now in his early seventies. Does nature inspire in him a spiritual faith? 'One likes to believe in something,' he replies after a moment of thought, 'but I believe there's something out there that's much bigger than I am. I've always had a sense of wonderment, and I am partly inspired, subdued and dominated by the landscape.' Not intimidated? 'Never. It's too beautiful.

'We're very well taken care of in Australia, we don't have any threats and we can afford to look after the country and our environment. It's very different in parts of Africa, or Bangladesh, where people are barely surviving. I think we have no reason to neglect our environment at all.'

He returns to his birthplace of Holland occasionally, but the urge to photograph eludes him there. 'Because it's so small and because every angle has been photographed, it's difficult to find something new.' Each time, he feels more strongly about the 'great privilege to be in Australia, to have come here at the right time'.

And although people rarely figure in his photographs these days, he says they are the key to a good shot. 'I'm working with pilots, people on stations, farmers, townspeople, publishers — it's great to work with people who are appreciative, who want to help me get the pictures I would like to get.

'It's obvious I'm getting old,' he adds, smiling, 'because I'm also getting sentimental. It's rather nice — it comes from having grandchildren I suppose.'

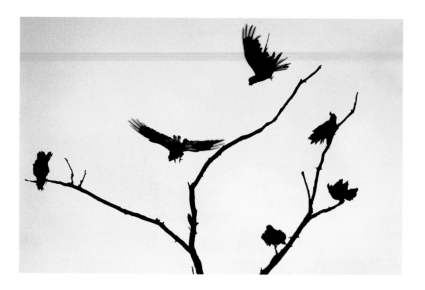

Black cockatoos fly to their roost as a storm approaches.

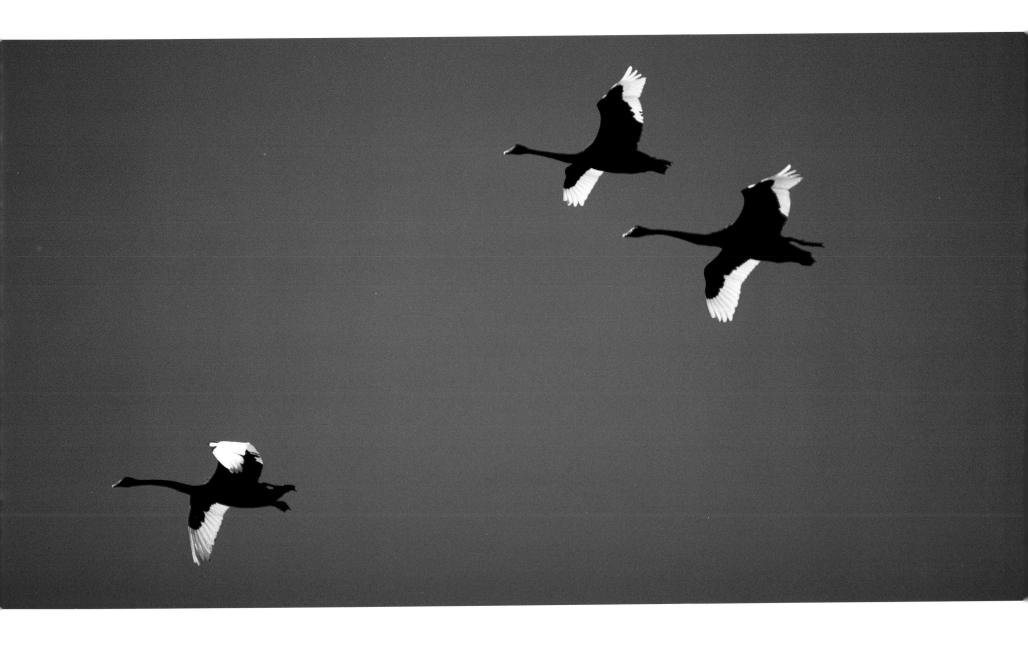

Elegant black swans are a frequent sight on the Swan River, Perth, Western Australia.

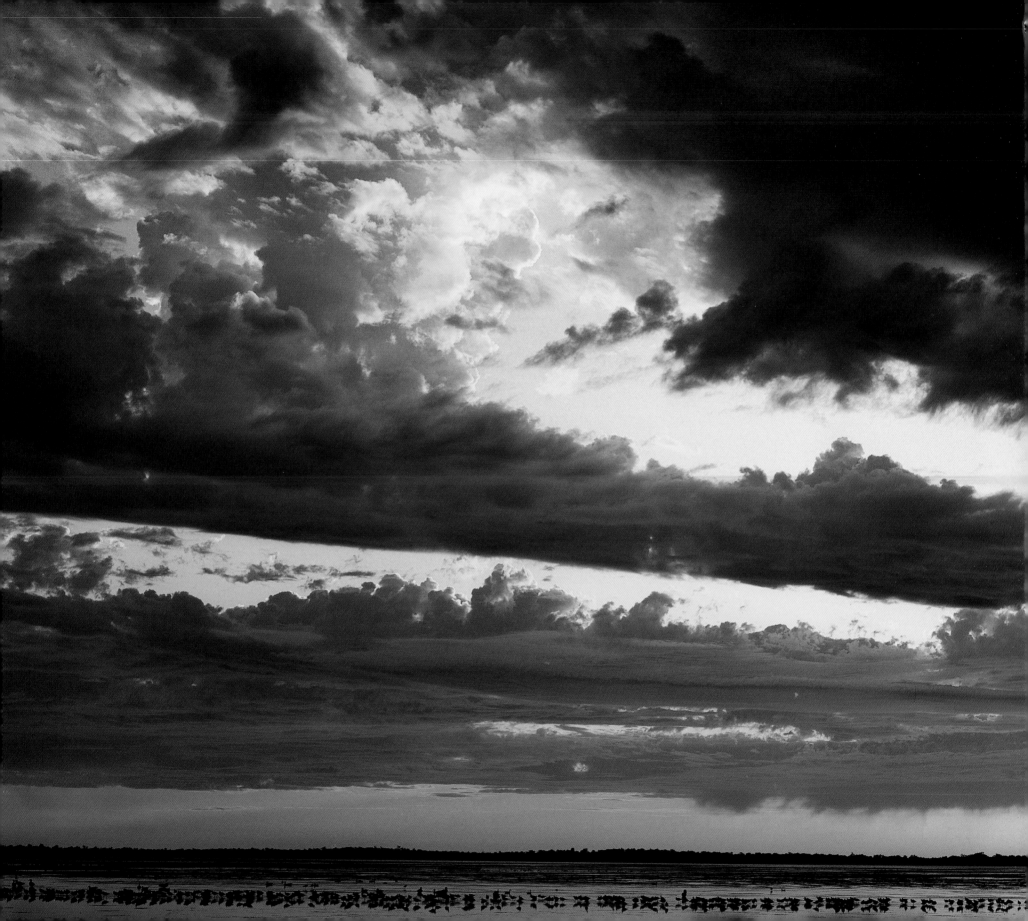

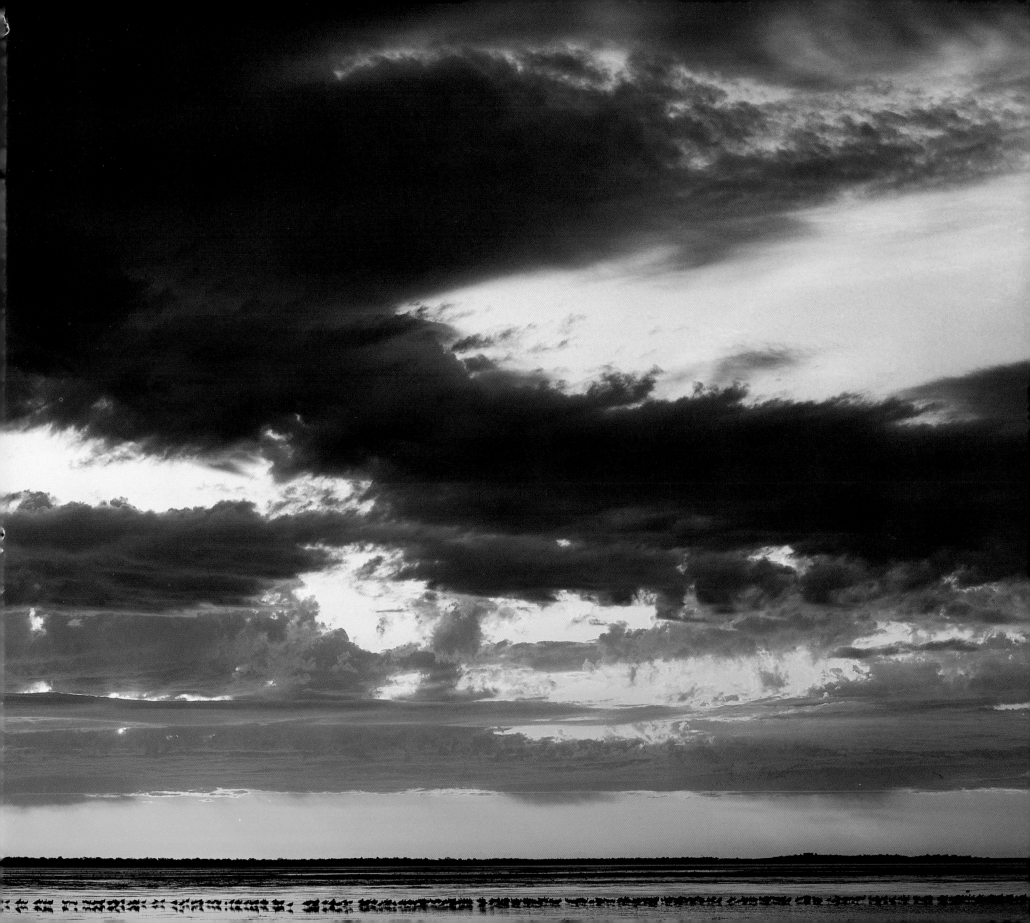

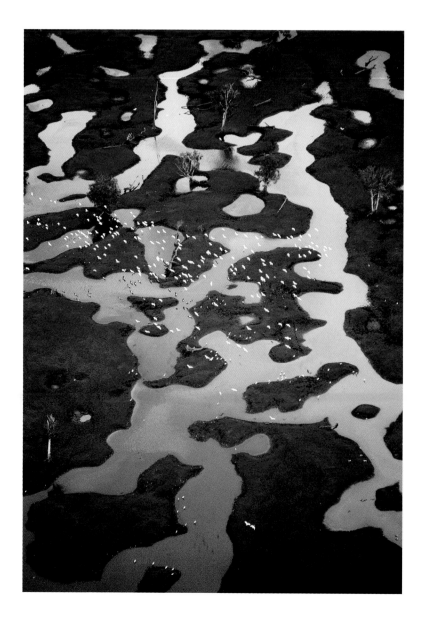

A cluster of white specks move across the sky above the nation's richest wildlife reserve at Kakadu National Park, Norther Territory. These corellas are heading for their favourite wetland roosts.

Previous pages: Teeming with waterbirds, Mandurah's estuary and lagoons are prime breeding grounds on Australia's south-western shoreline.

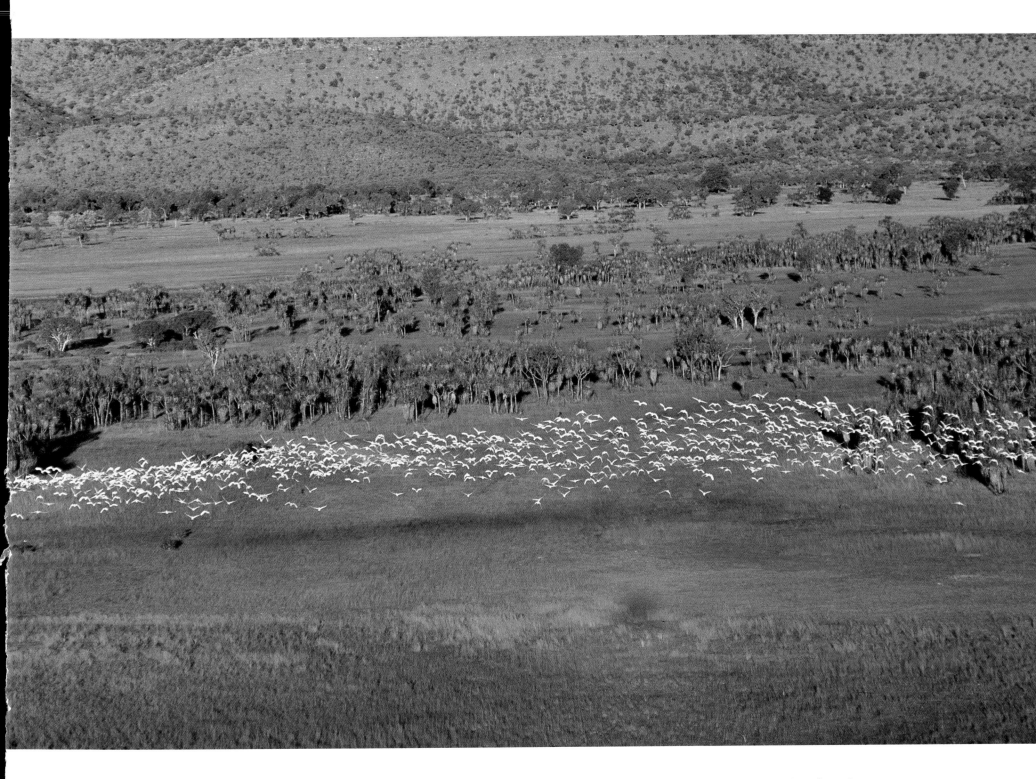

On dry plain country around the Keep River, Western Australia, corellas flock in their thousands to patches of ripe grass and acacia seed.

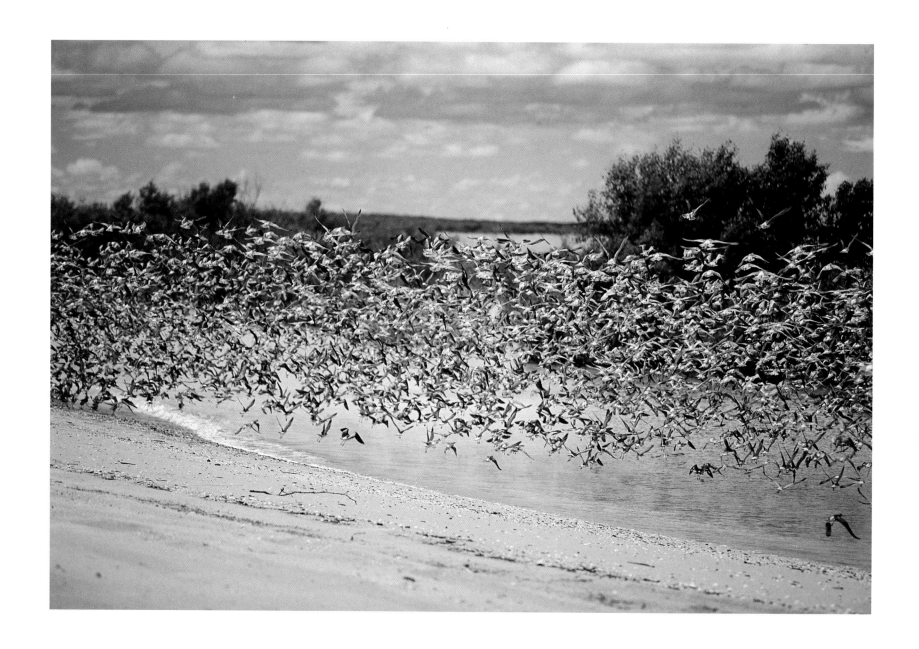

Flocks of wader birds in transit at Roebuck Bay and Eighty Mile Beach, near Broome, Western Australia. Every year, they cover incredible distances to migrate between Australia and China, Siberia and Alaska.

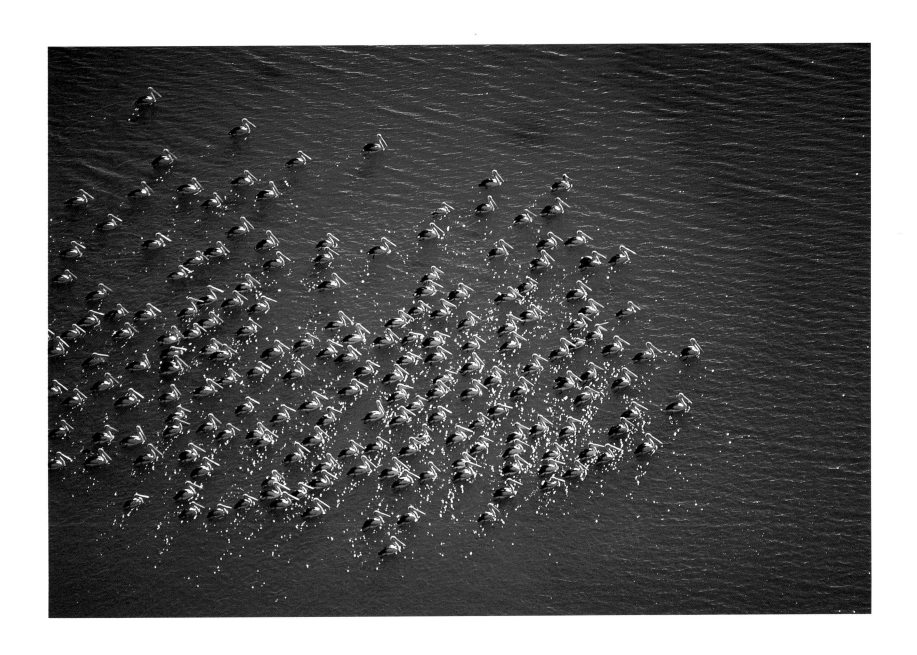

Australian pelicans converge on a small pool near Lake McLeod, north of Carnarvon, Western Australia.

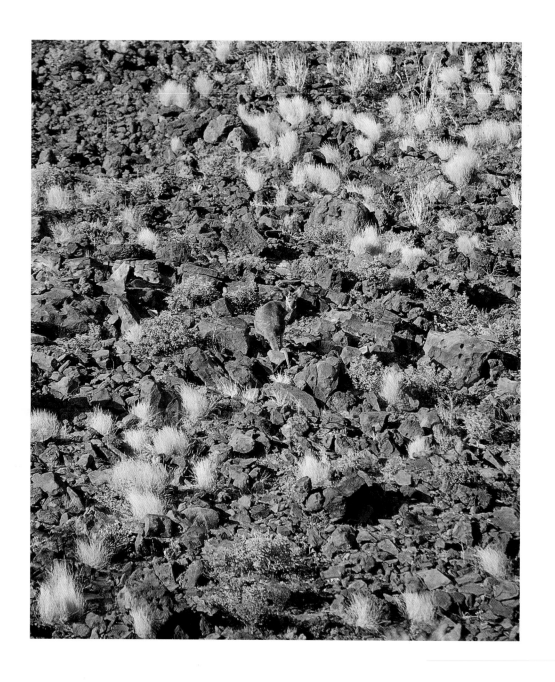

A lone marsupial pauses on a scree slope, surrounded by hardy tufts of spinifex and acacia shrubs. Kennedy Range National Park, Western Australia.

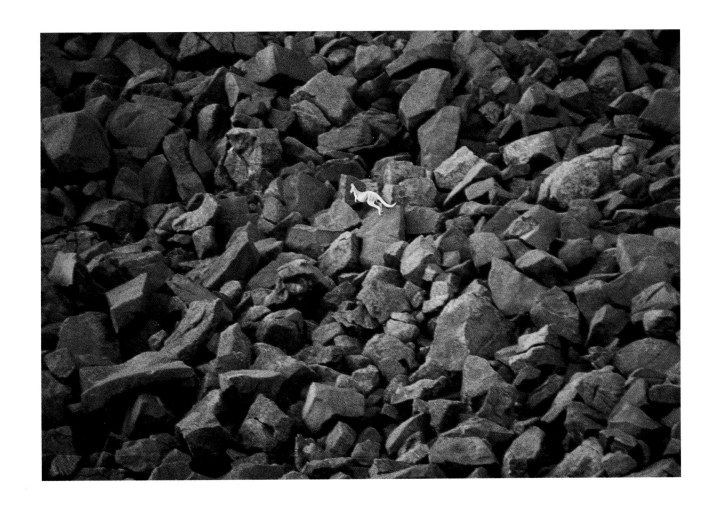

A more rugged habitat for this rock wallaby, or euro, on the Burrup Peninsula,
Western Australia.

ACKNOWLEDGEMENTS

The photographs in this book have been compiled with the assistance of Lyn, my wife, and Eva, our daughter, who assisted with scanning and layout.

People I would also like to thank are Jan and Penny Ende for flying me to parts of Australia inaccessible otherwise, Robin Stewart of Northam, the Royal Flying Doctor Service and Hamersley Iron. I would particularly like to thank Alan Fox for sharing his knowledge of the landscape and his assistance with the captions. Also to Vicki Laurie for her insight and patience in compiling the text for this publication.

All the photographs are as found, not manipulated or enhanced by computer. The natural beauty of the Australian landscape, I feel, deserves the optical reality to convey its beauty and uniqueness.

Richard Woldendorp

First published 2001 by
Fremantle Arts Centre Press
in association with Sandpiper Press
PO Box 158, North Fremantle
Western Australia 6159.
www.facp.iinet.net.au

Designer John Douglass, Brown Cow Design.
Consultant Editor Ray Coffey.
Printed by Tien Wah Press, Singapore.

National Library of Australia
Cataloguing-in-Publication data:

 Woldendorp, Richard, 1927- .
 Design by nature.

 ISBN 1 86368 349.

 1. Australia - Pictorial works. I. Laurie, Victoria. II. Title.

 919.4

The State of Western Australia has made an investment in this
project through ArtsWA in association with the Lotteries Commission.